ΩRT as 1™

Japanese Professional Illustrators - Vol.1

ART as 1™

ART as 1™ Japanese Professional Illustrators - Vol. 1

970 W. 190th St., Suite 270
Torrance, CA 90502 U.S.A.
Tel: 310-515-7100
e-mail: ask@ARTas1.com
www.ARTas1.com

Printed in Japan
ISBN-13: 978-0-9776143-0-1
ISBN-10: 0-9776143-0-1

Credits

Toshihiko Takabatake
President / Publisher

Paul Archuleta Whitney
Vice President
U.S. Sales & Licensing Director

Koji Ishikawa
Art Director / Book Design

Yumiko Tamura-Loose
Editor

Saki Omori
Translation

Maria Hummel
Copy Editor

**U.S. Art Sales & Licensing
Authorized Representatives:**
Eric S. Cygiel
Andrew L. Spitzer
Stanley Lozowski
Mark Schustrin
Lisa M. Beagles

Japan:

Hiro Shibata
Executive Director

Makoto Ohtsuki
Sales Manager

Misae Ohtsuki
Coordinator

Hiroko Saiki
Coordinator

* * * * * *

Toppan Printing Co., Ltd., Tokyo
Printer

ART as 1™

Japanese Professional Illustrators - Vol.1
(A Collection of 43 Top Contemporary Japanese Visual Artists)

Welcome to **ART as 1**™, a project that brings the American and Japanese art communities closer together as one, while exalting each unique artistic creation as the only one of its kind in the world.

As our global village becomes more interconnected and interdependent, old barriers fade away, distance, language, and cultural differences dissapear. **ART as 1**™ uses illustrative creativity as a common language.

While these 43 visual artists are all "Japanese Professional Illustrators," their mediums run the entire gamut, including acrylics, photography, oils, 3-D computer graphics, pastels, paper clay, pencil, pen & ink, found items, and more. These professional artists have created everything from petite, stamp-sized drawings to grandiose park monuments and stage set deigns.

While new to the American art market, many of these artists are household names in Japan. All of them are recognized as masters of their disciplines and crafts. There is a short biography on each artist, so that you may familiarize yourself with their creative approach, educational background, awards, and clients.

These stellar Japanese artists and their works are being presented as potential resources to bring new creativity to any project. I truly believe that in the coming together of our two cultures there lies an exciting opportunity for new and extraordinary creativity. Now, this chance is yours!

Toshihiko Takabatake
Publisher
Japan Publicity, Inc.

To help you discern which mediums each artist uses, please refer to this key which gives a description of the artist's skills:

W = Watercolors O = Oils A = Acrylics P = Pastels C =CG D = Digital Data

skill: **W** ☐ **O** ☐ **A** ☐ **P** ☐ **C** ☑ **D** ☑

Comments from Supporters

Having traveled to Japan numerous times and admired their culture, their people, their graphic designers and illustrators I welcome their extraordinary selection of talented artists to America.

Kurt Haiman
Founder & Sr. Partner
G2 Worldwide

"Truly, a breath of fresh air!"

Jim Miller
Associate Creative Director
Serino Coyne, Inc.

Comments from Supporters

Welcome Artists! When I was young the world seemed so large, but as times goes by I realize it really isn't that big after all. With all the new technology, our modern world becomes more manageable to see and understand.

I see that the need to create and fill the world with beautiful art is something we all share. Please take great pride and enjoy your new endeavors in the United States. I am sure it will be dearly appreciated by all who see them.

Cindy Freed
Director of Art Buying Services
DRAFT, Inc.

Today's American graphic design market is big, bold, growing and visually hungry for new ideas, influences and talent. The ART as 1™ book fulfills a need for fresh, powerful and colorful imagery. I believe the talent shown within will be welcomed by American art buyers, just as I welcome these artists to our community. This is a useful resource. I am particularly pleased that it displays the work of both long-established Japanese artists as well as the new and next generation of talent.

Gordon Kaye
Editor
Graohic Design USA Magazine

ART as 1

JAPANESE PROFESSIONAL ILLUSTRATORS - Vol. 1

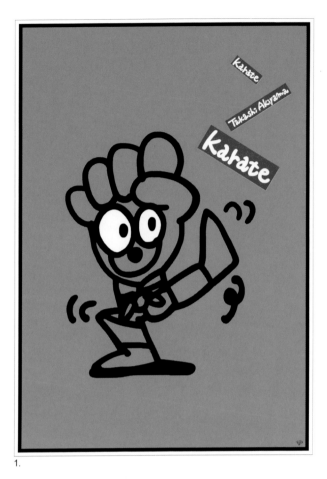

1.

Takashi AKIYAMA

E-mail: takashi_akiyama@ARTas1.com
URL: http://www.ARTas1.com/info/takashi_akiyama

skill: **W**☑ **O**☐ **A**☑ **P**☐ **C**☑ **D**☑

Born Nagaoka, Japan 1952
B.A., Tama Art University, Tokyo
M.A., Tokyo National University of Fine Arts and Music
Honorary Doctor of Philosophy in Art, (IOND)
Professor, Tama Art University

"We have such an unlimited appetite for communication. Illustration itself is primitive, thus, its capacity to communicate with others is immense," says Mr. Akiyama. As a prominent artist and a leader in art academia, he has influenced the Japanese creative circle for decades. He is a professor at Tama Art University, Tokyo, and on the jury of International Poster Exhibitions in Finland, Mexico, Italy, and the Ukraine.

CLIENTS

Recruit Co., Ltd., Honma Corp., Funabashi-shi Park Association, Turner Color Works Ltd., and many more...

AWARDS

Warsaw International Poster Biennial Gold Prize; Brono International Graphic Design Biennial Artia Prize; Africa Protection of Natural Environment Tunisia Embassy Prize; Mexico International Biennial of the Poster Honorary Mention Award; Helsinki International Poster Biennial Honorable Mention; New York Festival Design & Print Silver & Bronze 1995, and 1997-2001 Finalist Award, (*No More Nuclear Testing By India 1998*); United Nation DPI Award; The Art Directors Club (NY) 72nd Annual Awards 7th International Exhibition Distinctive Merit Award (*AIDS Campaign Poster*); and many more...

1. Karate

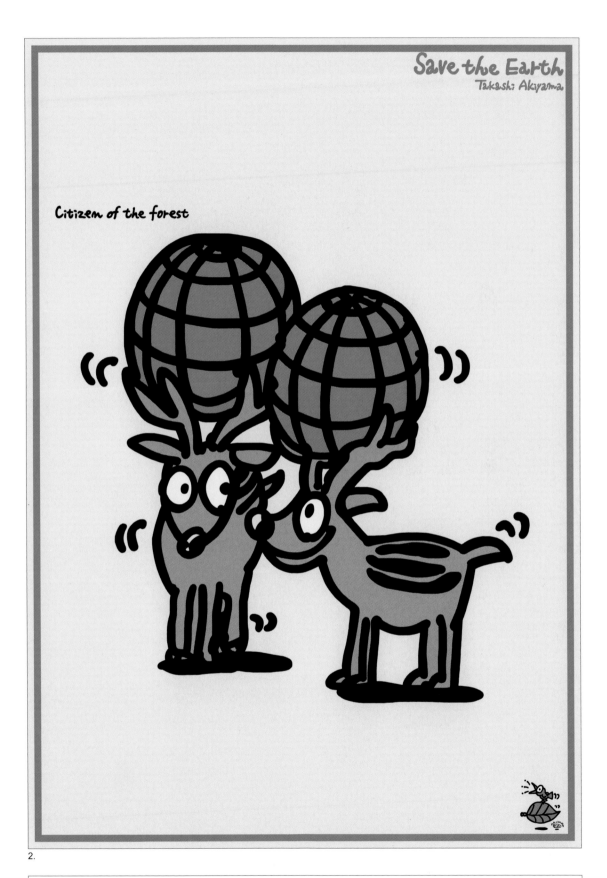

Citizen of the forest

2.

2. Citizen of the Forest

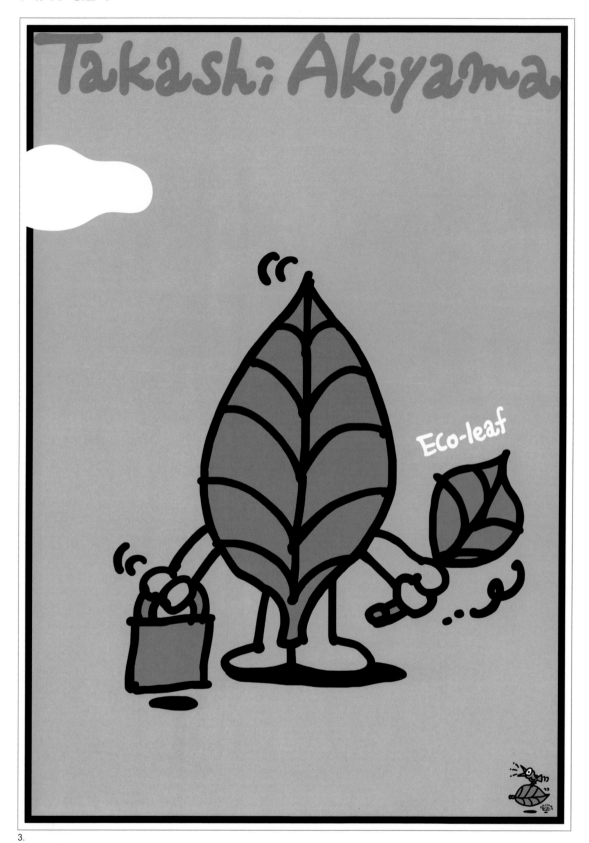

3.

3. Eco-leaf

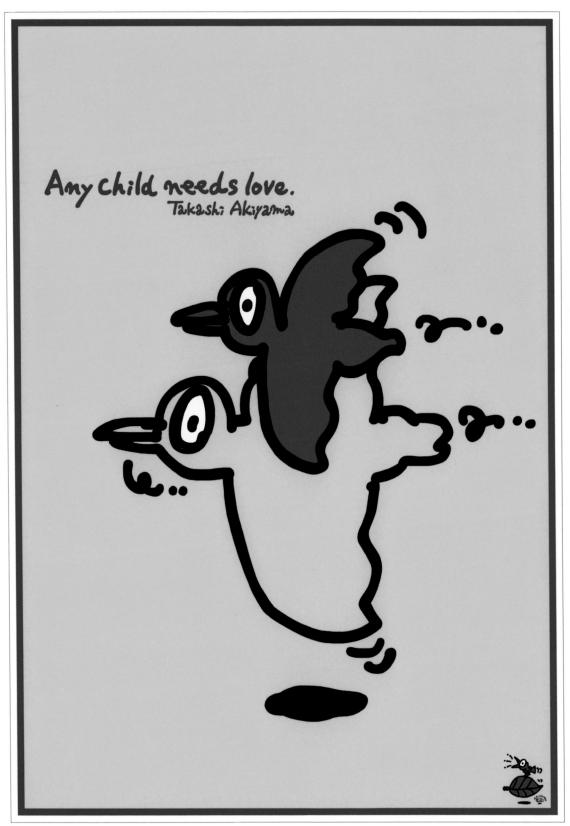

4.

1.

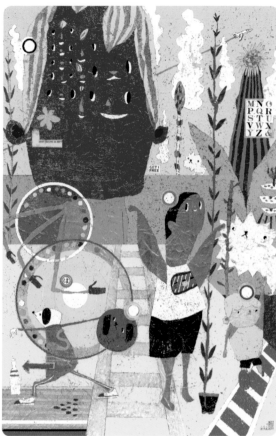

2.

Toshiyuki FUKUDA

E-mail: toshiyuki_fukuda@ARTas1.com
URL: http://www.ARTas1.com/info/toshiyuki_fukuda

skill: **W**☐ **O**☐ **A**☑ **P**☐ **C**☐ **D**☑

Design B.A., Osaka University of Arts

"My work gives people a happy sense of nostalgia. I try to infuse originality and mass appeal into my work at the same time," says Mr. Fukuda. His illustrations have appeared in numerous publications, on greeting cards, on T-shirts, at major events, in movie posters, and on record / CD covers throughout Japan. He illustrated the cover of the book, *The Minotaur takes a Cigarette Break* (by Steven Sherrill) and published the children's book, *Towerman* in collaboration with Marek Veronika, a Hungarian author.

CLIENTS
Suntory; UNICEF Japan, Mac People, UNESCO Japan, Kadokawa Shoten Publishing, Recruit, Benesse, Asahi HIT Com, Japan Broadcasting Corporation (NHK), Heiwa Paper, and many more...

AWARDS & SHOWS
UNESCO Japan Character Competition Prize; EST1 Graphic Art Exhibition Grand Prize; Japan Art & Culture Association Prize; Illustration CHOICE Prize; and many more... Solo shows at Pinpoint Gallery, Utrecht (Tokyo), HB Gallery (Tokyo), Gallery Paraiso, Manifesto Gallery, Gallery Centennial, Gallery vie (Kobe), Keibunsya (Kyoto), Kanakana (Nara). Mr. Fukuda has participated in many group shows, as well.

1. The Super Hero KUMAN 2. The Gearwheel of the Town

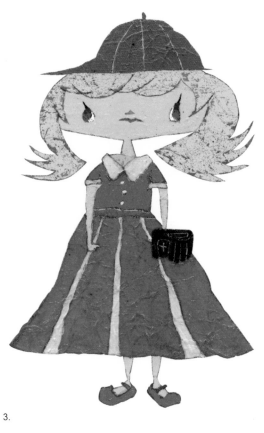

3.

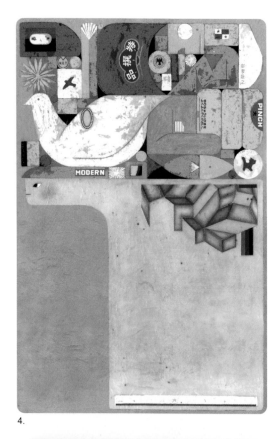

4.

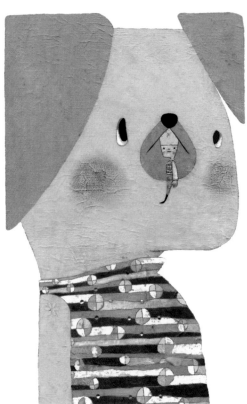

5.

6.

3. Baseball Girl 4. The Unknown 5. The Hungry Doggy 6. The Girl in the Hat

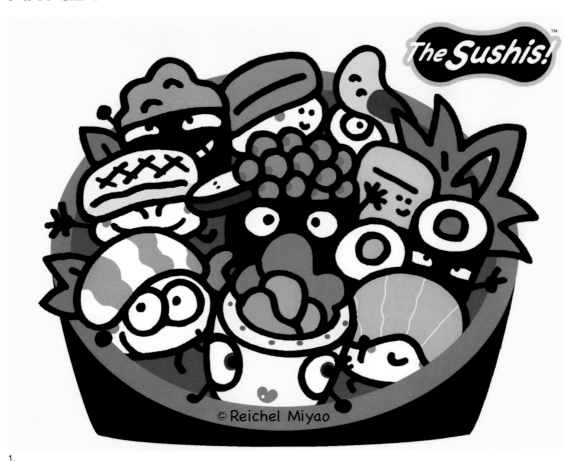

The Sushis!™

© Reichel Miyao

1.

Reichel MIYAO

E-mail: reichel_miyao@ARTas1.com
URL: http://www.ARTas1.com/info/reichel_miyao

skill: **W**☐ **O**☐ **A**☐ **P**☐ **C**☑ **D**☑

Design B.A., Tama Art University, Tokyo

"My characters have a universal appeal and an intriguing power that energizes the audience's spirits," says Ms. Miyao. While running her design firm in Tokyo, she has created many characters for major corporations over the decades and is acclaimed as one of the leading artists in Japan. Her new character-based work, **The Sushis!™** was created with animation in mind. Each Sushi character has a bold presence and "personality" to attract the attention of a wide audience, especially young children and adolescents.

CLIENTS

Hitachi, Japan Broadcasting Corporation (NHK), Fuji Television Network, Nippon Television Network, Kodansha, Shogakukan, Benesse, Gakken, Fusosha, House Shokuhin, Meiji Seika Kaisha, Bourbon, Mister Donut, Oji Paper Group, The Japan Crown, Takeda Pharmaceutical, Taisho Pharmaceutical, and many more...

1. The Sushis!™

AA1-06-003

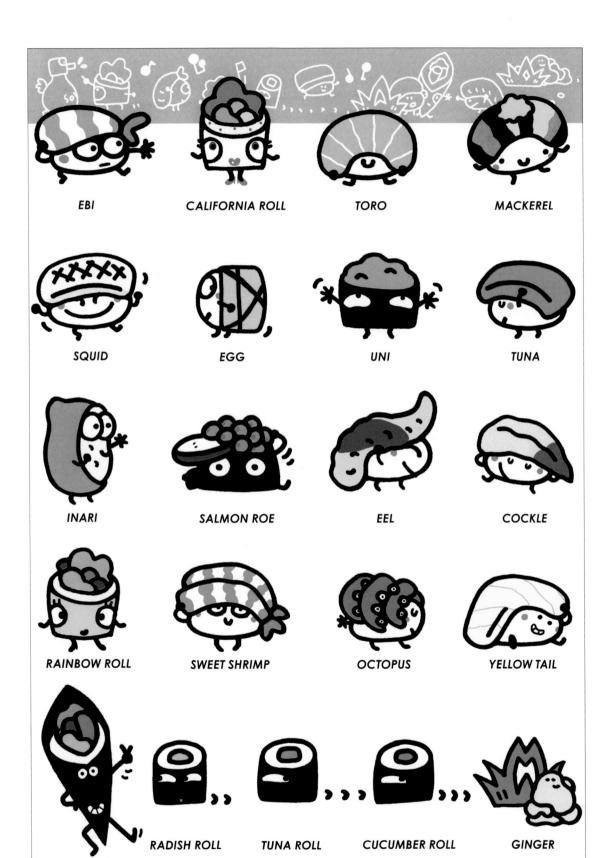

EBI

CALIFORNIA ROLL

TORO

MACKEREL

SQUID

EGG

UNI

TUNA

INARI

SALMON ROE

EEL

COCKLE

RAINBOW ROLL

SWEET SHRIMP

OCTOPUS

YELLOW TAIL

HAND ROLL

RADISH ROLL

TUNA ROLL

CUCUMBER ROLL

GINGER

2.

2. The Sushis!™

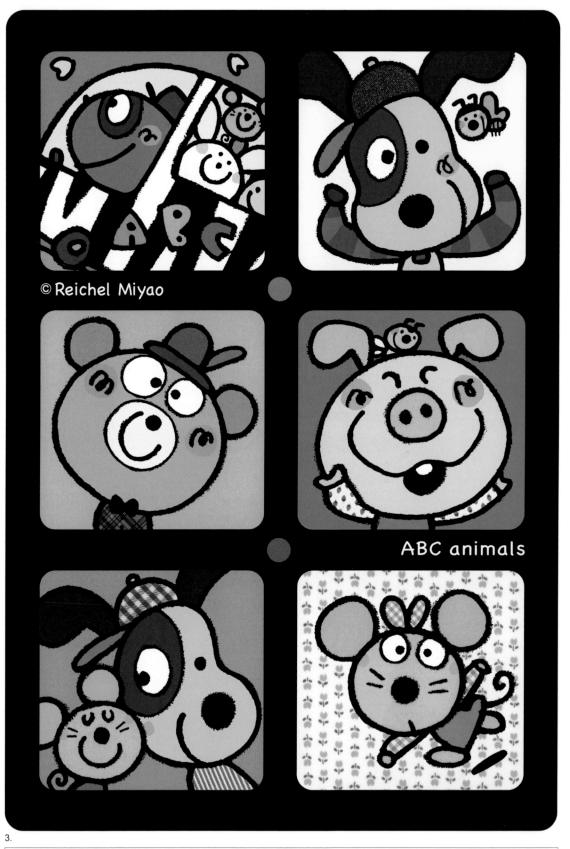

© Reichel Miyao

ABC animals

3.

3. ABC animals

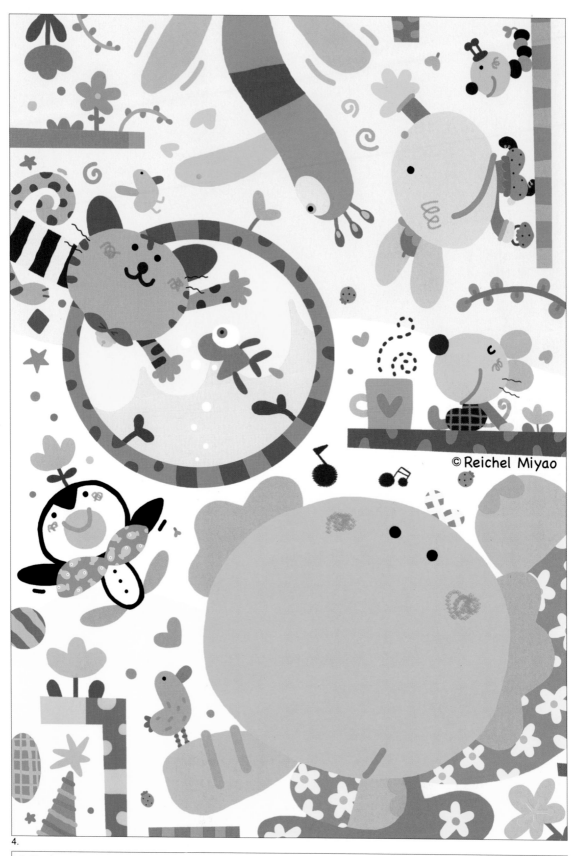

© Reichel Miyao

4.

4. Rambunctious Kids

1.

Hiroshi YOSHII

E-mail: hiroshi_yoshii@ARTas1.com
URL: http://www.ARTas1.com/info/hiroshi_yoshii

skill: **W**☐ **O**☐ **A**☐ **P**☐ **C**☑ **D**☑

Mr. Yoshii is one of the most acclaimed digital artists in Japan. He freelances as an illustrator and has created various characters for major TV programs, commercials, corporate websites, campaigns and events. Yoshii specializes in crystallizing characters for his clients' needs with little direction. "My three-dimensional characters are created by a harmonious combination of beauty, ludicrousness, and humor." Member of **The Society of Publishing Arts** and **Digital Image**.

CLIENTS

Character design and development, visual promotion and animation: Gloria Jean's Coffee (U.S.A.), Total (France), Matsushita Electric Works, Japan Telecom, TV Tokyo, Nippon Television Network, House Foods, Mac Fan Expo in Kansai 1997, E3/Tokyo 1996, Kodak Japan, Maxell, and many more… **Covers:** French monthly magazine **SVM Mac**, **Reading** (Scholastic USA), **Quarterly CD-Rom Nikkei Corporate Information** (Nihon Keizai Shimbun), **WWW Yellow Pages** (AI Publishing), illustrations for the column pages of French weekly magazine **Le Point,** and many more…

1. Pu-chan

AA1-06-004

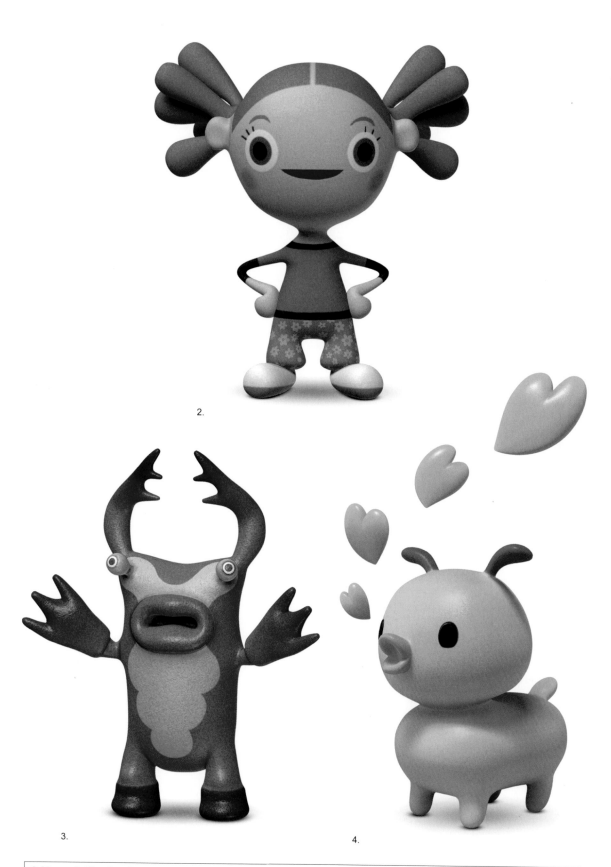

2.

3. 4.

2. Mary 3. Alien Stag Beetle 4. Kawaii

© 2006 Hiroshi Yoshii

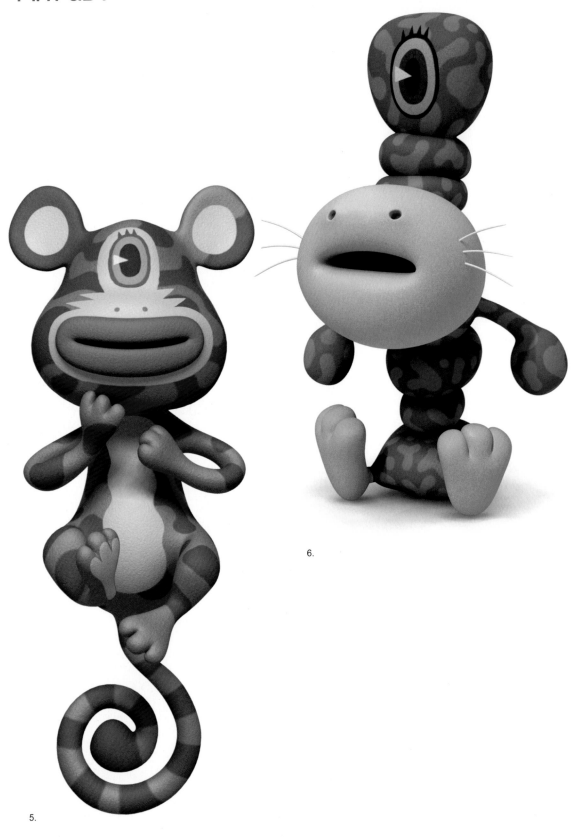

5.

6.

5. The One-eyed Monkey 6. Woo

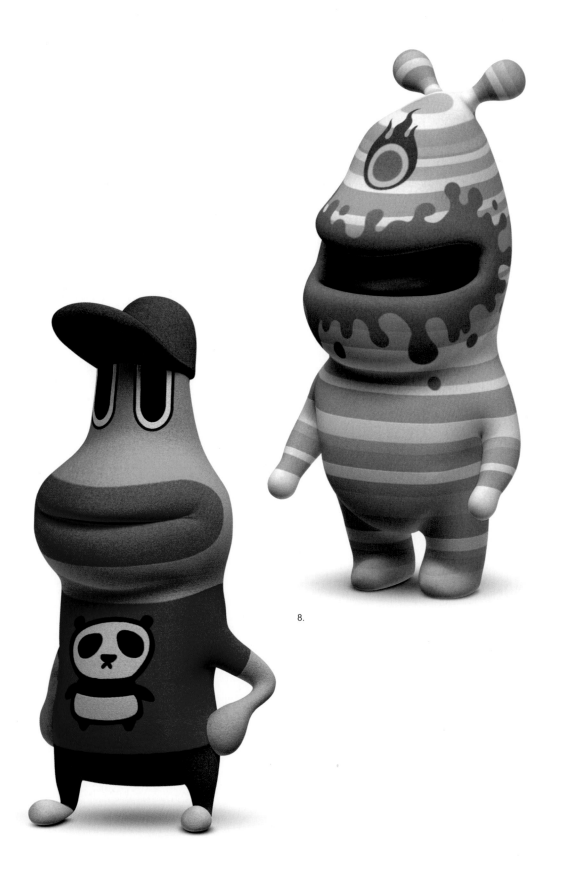

7.

8.

7. Panda Boy 8. Stripes

1.

Radical SUZUKI

E-mail: radical_suzuki@ARTas1.com
URL: http://www.ARTas1.com/info/radical_suzuki

skill: **W**☐ **O**☐ **A**☐ **P**☐ **C**☑ **D**☑

Mr. Suzuki's attractive female characters express a delicate sensitivity to human form and emotion, while personifying modernity. His new characters are ready to inhabit the world of animation, the music industry, and even live-action films. Suzuki's illustrations appear throughout Japan in advertisements, publications, and magazines, as well as at major events.

CLIENTS

Character design and visual promotion for: Shochiku Movie **OL Chushingura**, Yomiuri Shimbun Newspaper and National Science Museum, Tokyo, **Dai Kao (Great Face) Exhibition**, Temp Staff **Job Cheki!**, and many more...

AWARDS & SHOWS

The Art Directors Club 79th Annual Awards 2001 Distinctive Merit Award; The Art Directors Club 81st Annual Awards 2002 Merit Award; The 2005 Creativity 35 Gold Medal Award (**The Goddess of Rubbers**); The 2001 Creativity 31 Gold Medal Award (**Friend Etiquette**); HKDA Design 2000 Show Gold Prize (Hong Kong); 13th Lahti International Poster Exhibition (Finland); 14th UNESCO International Poster Exhibition (France); 11th Chaumont International Poster Festival; 15th **Humor and Caricature** International Biennial (Bulgaria); Entered Graphisme (France); Internet Graphic Design Competition Encouragement Prize; and many more...

1. Yoko in Summer

AA1-06-005

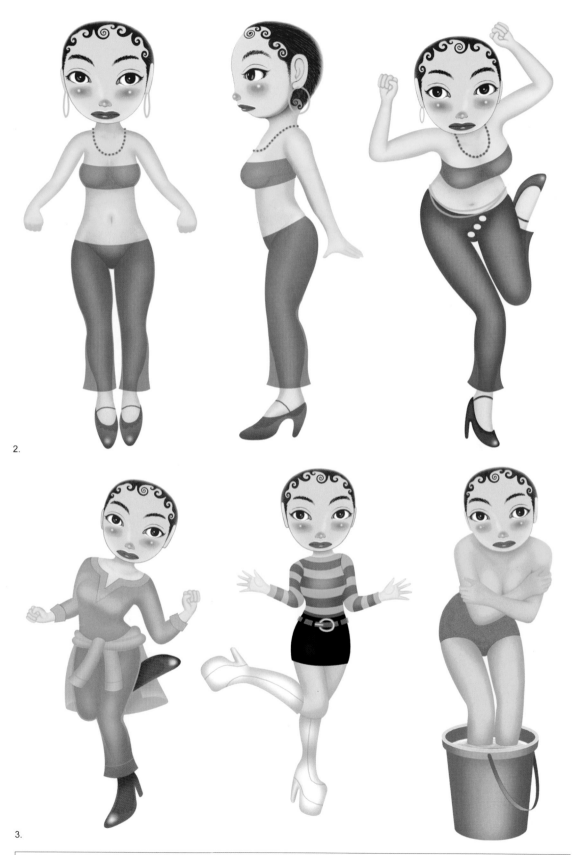

2.

3.

2. Yoko Pose No.1 ~ 3 3.Yoko Pose No.4 ~ 6

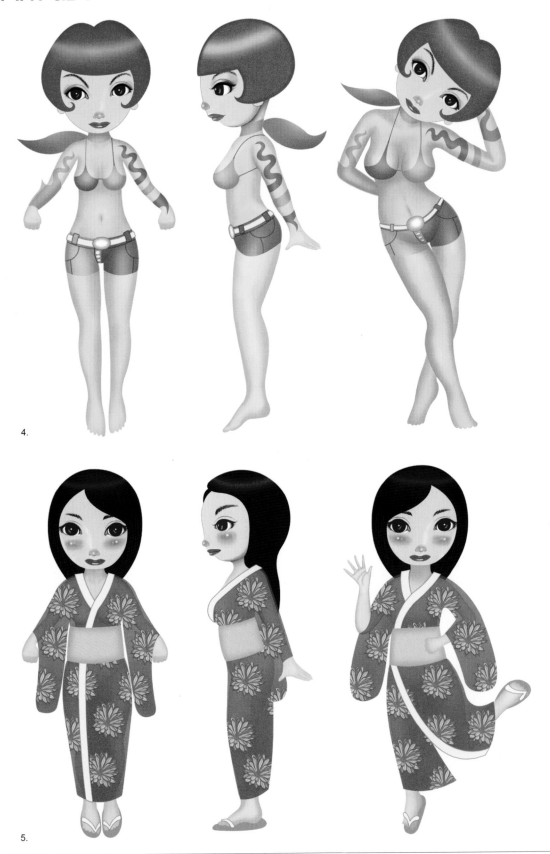

4.

5.

4. Ann Pose No.1 ~ 3 5. Shino Pose No.1 ~ 3

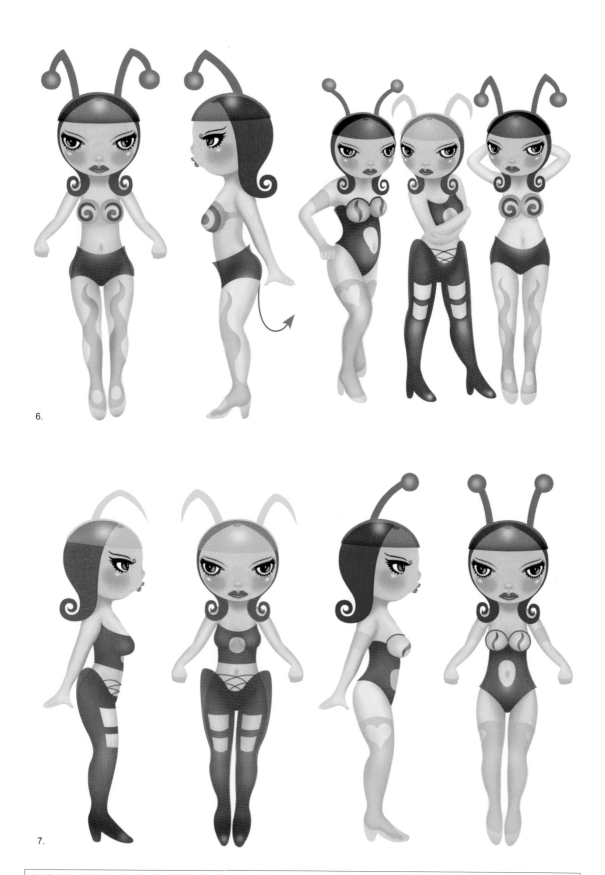

6. PusPus Gira Pose No.1 ~ 2 7. PusPus Bera Dora Pose No.1 ~ 2

1.

Takashi SEKIGUCHI

E-mail: takashi_sekiguchi@ARTas1.com
URL: http://www.ARTas1.com/info/takashi_sekiguchi

skill: **W** ☑ **O** ☐ **A** ☑ **P** ☐ **C** ☐ **D** ☑

B.A., Tama Art University, Tokyo

Mr. Sekiguchi has been an outstanding member of the "ManGArt" group since 1986, whose aim was to fuse the aesthetic and conceptual approach of *manga* (comics) and art into one genre. His subject matter exposes the darker facets of humanity, such as crime and violence with a sharp but incisive wit. Member of **The Japan Cartoonists Association and Japan Graphic Designers Association (JAGDA)**.

CLIENTS
Publications: Wild Bird Society of Japan award-winning book **Miru Yacho-ki (watching wild birds) Vol. 1 - Vol. 20**; Art Box Takashi Sekiguchi Manga Collection **Freeze!**; Asahi Shimbun serialized column **My Point of View – Weekend**; and more...

AWARDS & SHOWS
International Poster Biennale in Mexico 3rd Place Prize; 11th Chaumont Poster Festival in France 3rd Place Prize; World Cartoon Contest in Taiwan "Courage" Award; 5th Humorous Advertisement Contest Top Excellence Prize; The Art Directors Club (NY) Annual Awards ('92, '93 and '94) Merit Awards Tehran International Cartoon Biennial; and many more... Exhibitions at Warsaw National Caricature Museum Contemporary Japanese Cartoon Exhibition and more...

1. WAR!

AA1-06-006

2.

2. Terrorist

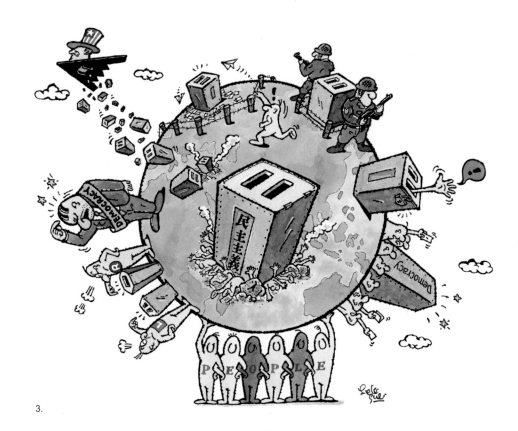

3.

4.

5.

3. Democratic Election 4. Ecology 5. Camouflage

6.

6. Animal Characters

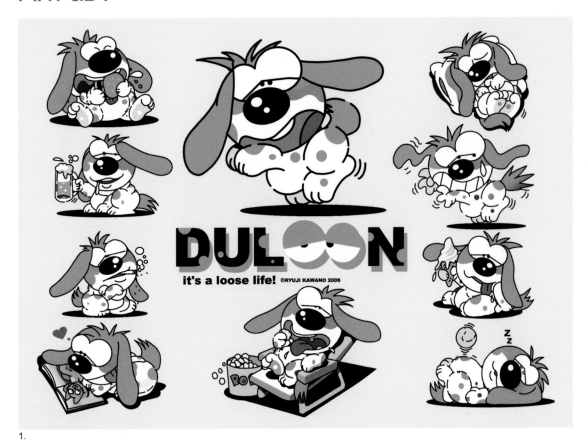

1.

Ryuji KAWANO

E-mail: ryuji_kawano@ARTas1.com
URL: http://www.ARTas1.com/info/ryuji_kawano

skill: **W**☐ **O**☐ **A**☐ **P**☐ **C**☑ **D**☑

Econ. B.A., Kanagawa University

Mr. Kawano's insatiable curiosity has kept him motivated, and in his own words, he "looks, reads, listens, talks, and acts *out*: these are my principles in order to have my artistic sensitivity well maintained." Within the feast-or-famine climate of the Japanese creative industry, he has freelanced as a leading illustrator for several decades. Mr. Kawano has published six illustrated children's books with major publishers. He is also dedicated to creating illustrations for elementary school textbooks in Japan. He is a member of **the Japan Children's Book Artists Society** and a founder of the website for freelance illustrators called **e-space**.

CLIENTS

Hitachi, Yamaha Music Foundation, Konica Minolta Japan, Tsukuda Original, Mitsui Oil, Lion, Tokyo Gas, Sato Pharmaceutical, Mainichi Newspapers, Osaka Shoseki, and many more...

AWARDS & SHOWS

My Character Exhibition Award of Excellence and more...
Selected exhibitions at Harajuku Sekiun Gallery (Tokyo) **e-space: Calendars** and **The Horizon of Imagination**; Yamawaki Gallery(Tokyo) **e-space Exhibition**; and many more...

1. Duloon

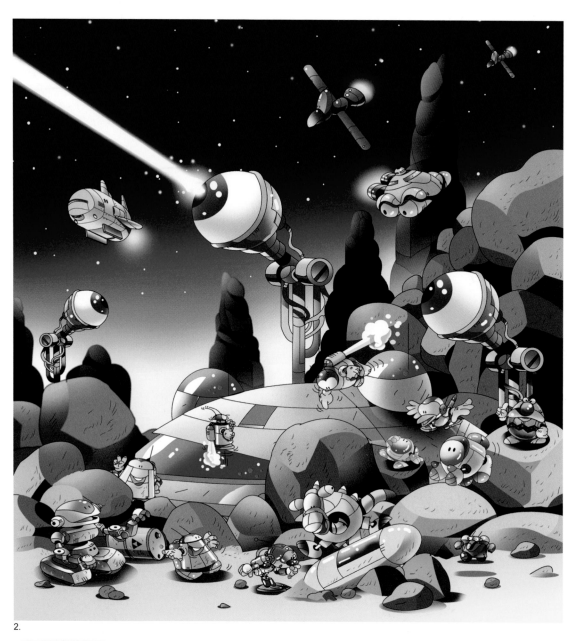

2.

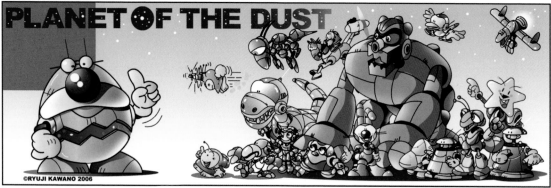

PLANET OF THE DUST

©RYUJI KAWANO 2006

3.

2. 3. PLANET OF THE DUST

© 2006 Ryuji Kawano

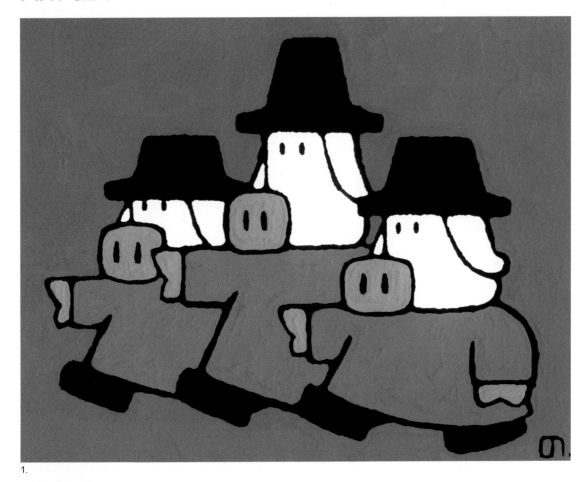

1.

Norio HIKONE

E-mail: norio_hikone@ARTas1.com
URL: http://www.ARTas1.com/info/norio_hikone

B.F.A., Tokyo National University of Fine Arts and Music

skill: **W**☐ **O**☐ **A**☑ **P**☐ **C**☐ **D**☑

It wouldn't be an exaggeration to say that nearly every Japanese person from every generation has seen Mr. Hikone's recognizable characters, which have appeared in numerous TV commercials over the years. As an illustrator and an animator, he is arguably one of the most influential artists in the Japanese creative circle. One of his characters, ***Karl Ojisan (Uncle Karl)***, created for the major Japanese confectionary company, Meiji Seika Kaisha still remains a celebrated and popular character, even after thirty years of continued use. Before becoming a freelance artist, Mr. Hikone worked as an animator for Toei Animation (called "Toei Doga Animation" at the time) as well as Mushi Production.

CLIENTS
Numerous character designs and developments for major corporations: Toyota, Nintendo, Seiko, Hitachi, Sumitomo Trust & Banking, Suntory, Nisshin Food Products, Meiji Seika Kaisha, Japan Broadcasting Corporation (NHK), Toyoeizai, Cosmo Oil Group, Parco, and many more...

1. Heading for Tomorrow

AA1-06-008

2.

2. Show Boat

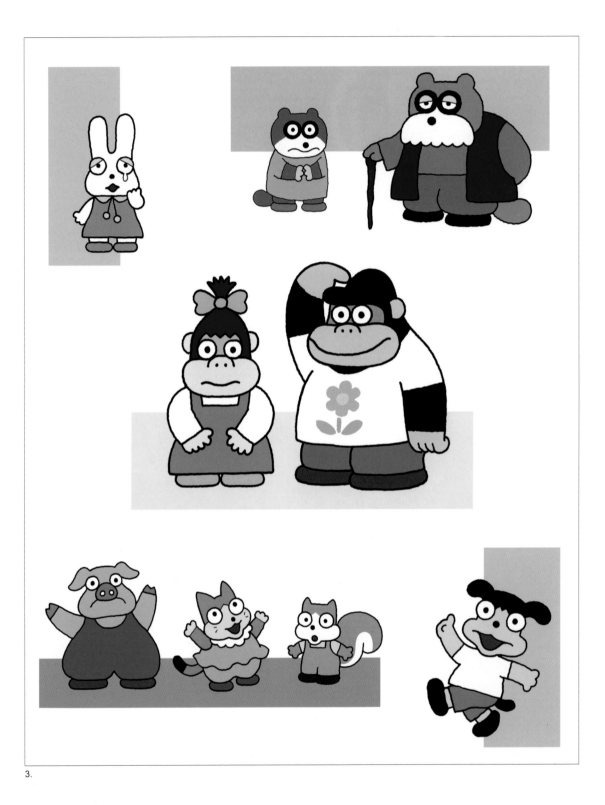

3.

3. Gorika & Gorillo

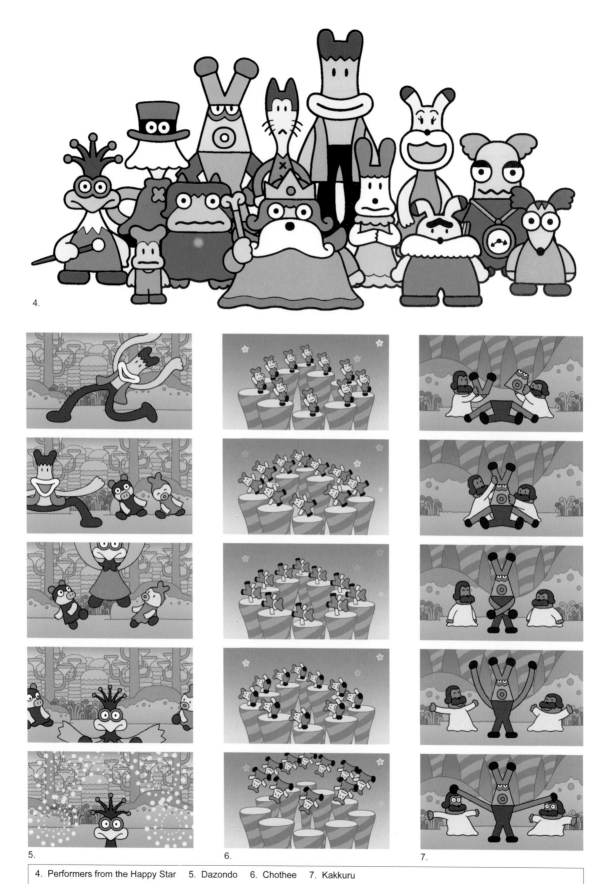

4.

5.

6.

7.

4. Performers from the Happy Star 5. Dazondo 6. Chothee 7. Kakkuru

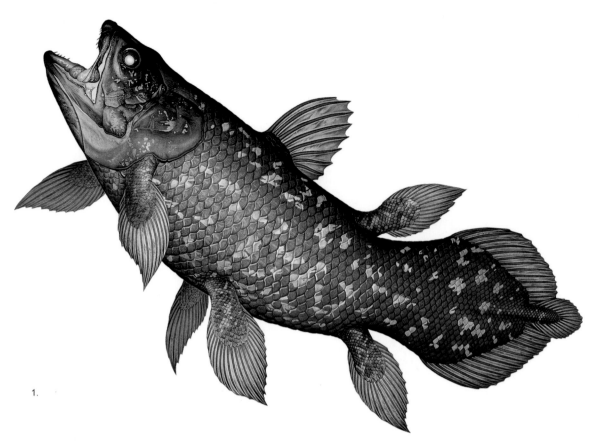

1.

Susumu UCHIDA

E-mail: susumu_uchida@ARTas1.com
URL: http://www.ARTas1.com/info/susumu_uchida

skill: **W**☐ **O**☐ **A**☑ **P**☐ **C**☐ **D**☐

If you wanted a rendering of "a middle-aged striped pigfish who seems to be falling in love with another fish," then Mr. Uchida would be your man. He specializes in fish illustrations and other realistic depictions of the world around us. Mr. Uchida's hyper-realism brings his fishes to life with dynamic compositions, graceful colors, and such an attentiveness to perception that you would swear you could taste, touch, and smell them. He is also exceedingly familiar with the natural habits of fish and extraordinarily knowledgeable of the world's fishing cultures. His works have appeared in a wide variety of publishing, advertising, and entertainment industries.

CLIENTS

Alaska Travel Industry Association, Ricoh Japan, Shochiku, Nikkei Money, Shogakukan, Tokyu Hands, Tokyu Land Corporation, Shinyokohama Raumen Museum, Yokohama Takashimaya, Yokohama Rubber, and many more...

1. Coelacanth

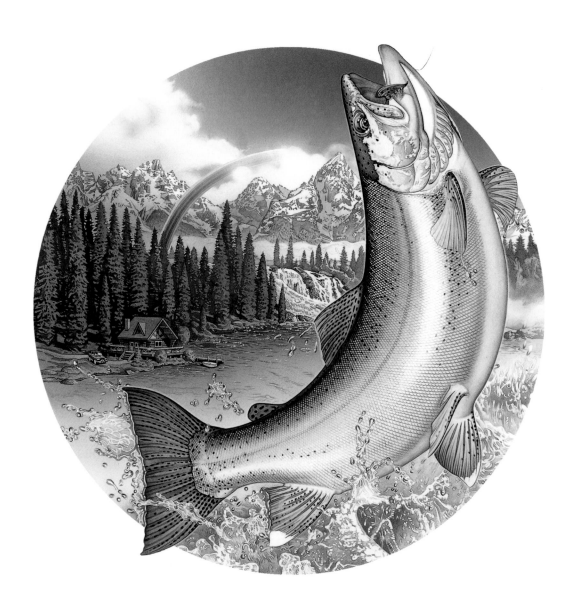

2.

2. Rainbow Trout

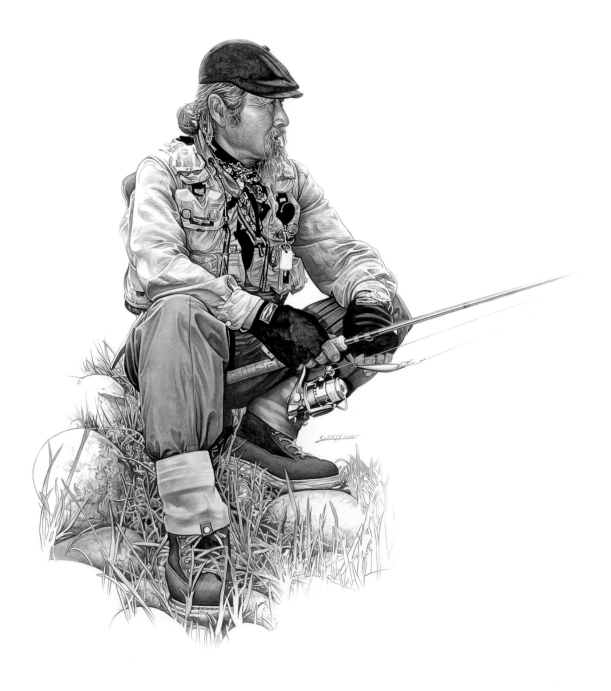

3.

3. Fisherman

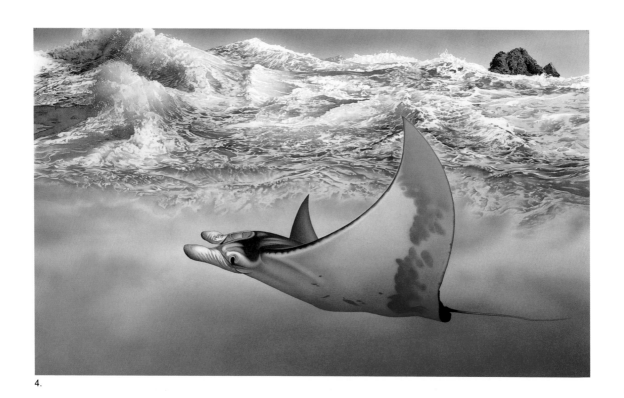

4.

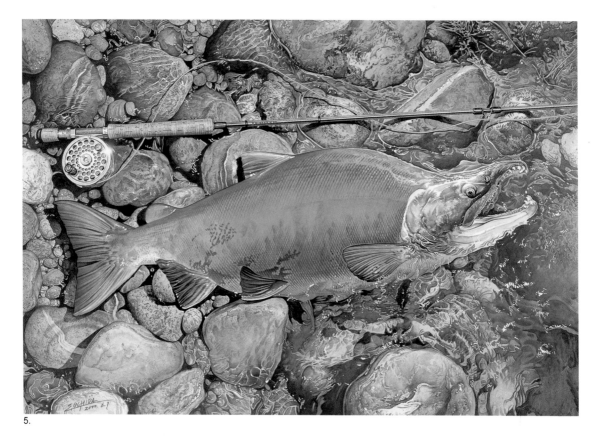

5.

4. Manta 5. Red Salmon

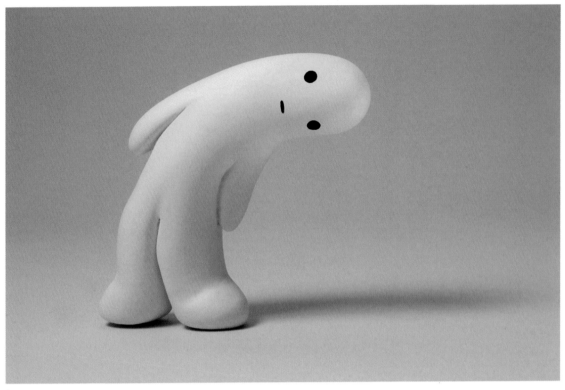

1.

Makoto OSANAI

E-mail: makoto_osanai@ARTas1.com
URL: http://www.ARTas1.com/info/makoto_osanai

skill: **3-dimensional**

Mr. Osanai has been praised for his creations in a wide range of fields including character design, children's educational publishing, broadcasting, and advertising. Many of his cuddly characters (made of clay and paper) have become icons for major Japanese corporations and popular television programs. In 2001, the character "**ONE**" was created for a publication and since then it has become acclaimed throughout Japan and Korea. Mr. Osanai is participating in The Tribute 21 Project, which provides children around the world with educational and cultural opportunities. He has had a solo show in Tokyo and Kobe every two years.

CLIENTS

Mitsubishi Electric, Central Japan Railway, Shogakukan, Kodansha, Shueisha, Ezaki Glico, Japan Broadcasting Corporation (NHK), Fuji Television Network, Asahi Broadcasting Nagano, Benesse, Gakken, Tokyo Shoseki, Kobun Shoin, Meito, Sekaibunka Publishing, Shobunsha Publications, and many more...

Publications: *One*, *QC* (published by Nijuni), and more...

1. one - What's Up?

AA1-06-010

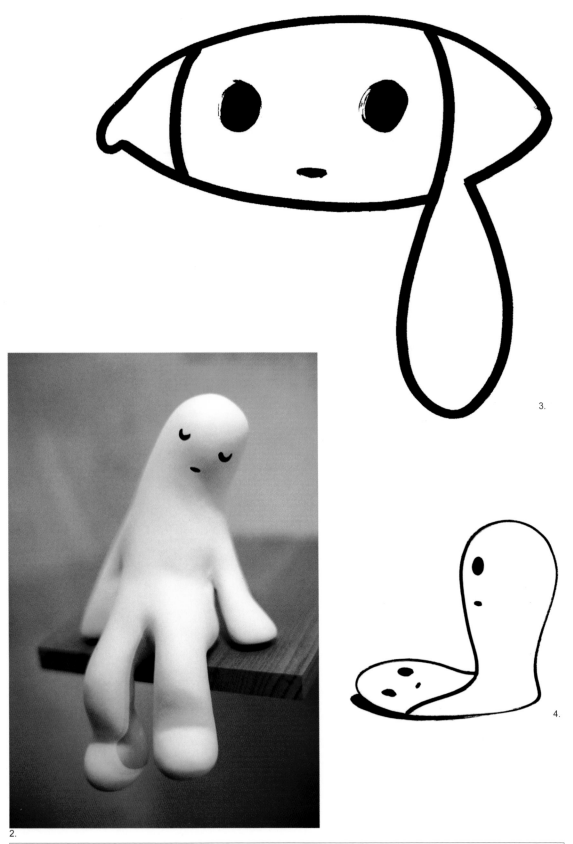

2. one - Thinking of You 3. one - Drawing 4. one - Drawing

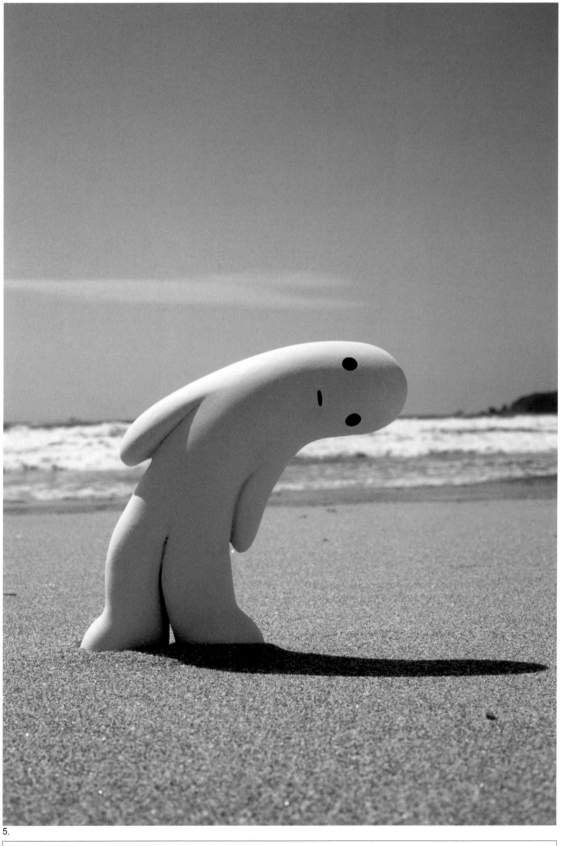

5.

5. one - At the Beach

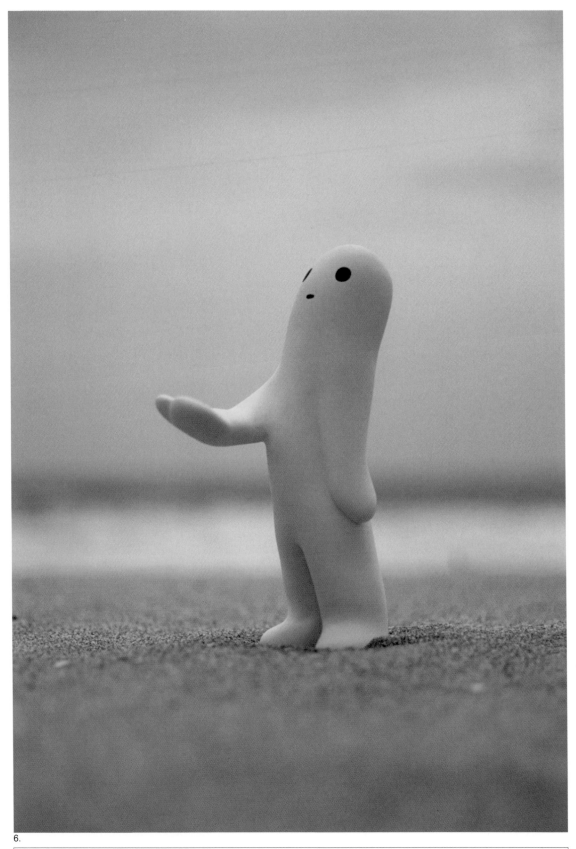

6.

6. one - Reach Out Your Hand and It Will Come

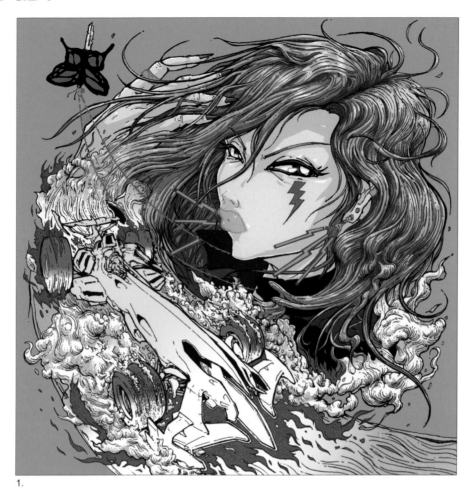

1.

IMAITOONZ

E-mail: imaitoonz@ARTas1.com
URL: http://www.ARTas1.com/info/imaitoonz

skill: **W**☐ **O**☑ **A**☑ **P**☐ **C**☐ **D**☑

B.F.A., Tama Art University, Tokyo

"I perceive that *manga* and graffiti art are aesthetic symbols of creativity and they have contagiously spread across world cultures," says Mr. IMAITOONZ. He has created his own alternative formalism and expressionism in his character designs, manga / comics, and illustrations. For the internationally acclaimed animation film, **DEAD LEAVES** (now available in the U.S. and Europe on DVD), he did project planning, screenplay, and character designs in collaboration with Production I.G.. His role in the creation of this movie has earned him an unparalleled reputation.

CLIENTS
NIKE Presto (animation), MTV Japan (**Top of Japan** opening animation), Reebok (**Reebok x And A x IMAITOONZ** model shoes), SEGA (arcade game **Fighting Vipers 2** character design), Medicom Toy (**KUBRICK**), Suntory, and many more…

AWARDS & SHOWS
The Ueno Royal Museum in Tokyo and Suntory Museum in Osaka **Gundam: Generating Futures** ('05); Labline TV (Tokyo) **YUTOONZ 1st. MIX** ('05); BEAMS Tokyo, Shibuya Parco Part 3 (Tokyo) **Devilman Illustration Exhibition**; Sapporo C.A.I. Gallery; and many more…

1. OVAL OVER

AA1-06-011

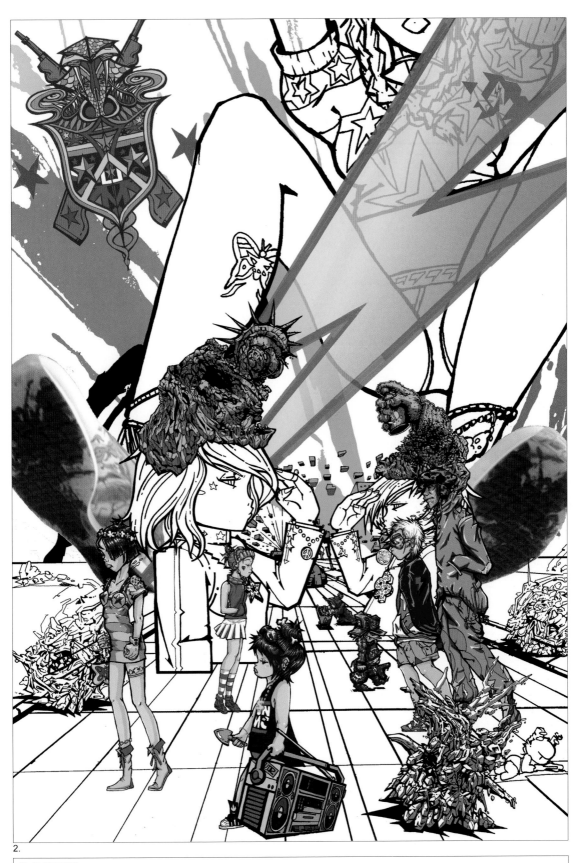

2.

2. X-FADERS

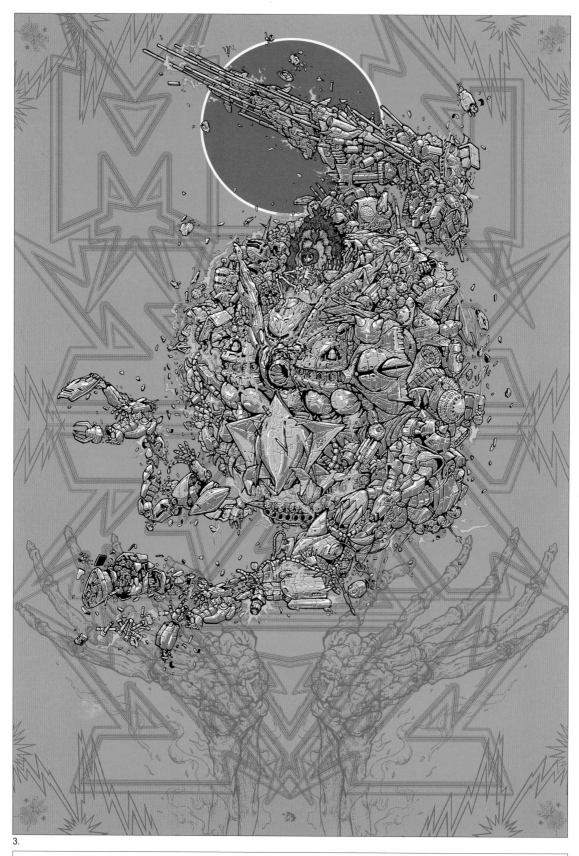

3.

3. MONSTER BALL

4.

4. SUGIURA HAND

1.

IEGAMO

E-mail: iegamo@ARTas1.com
URL: http://www.ARTas1.com/info/iegamo

skill: **W**☑ **O**☐ **A**☐ **P**☐ **C**☐ **D**☑

"I attempt to create wonders that nobody has ever seen before here on Earth, or even in this dimension," says Ms. Iegamo. Indeed, her outlandish creatures play in bizarre worlds but are positive caricatures of our own life and social patterns. Her shticky frog character frequently appears in her comics and acts like a big buddy while showing his true frog-nature as frolicking and fun. She has expertise in computer drawings and her penned illustrations have a fantasy world feel to them.

CLIENTS
WFP (World Food Program) Charity Forum 2001 (poster), Zoorashia - Yokohama Zoological Gardens (coloring book).

AWARDS & SHOWS
Japan Illustrators Association **JIA Exhibition** ('05) and J trip art Gallery (Tokyo) **Exhibition of Four Artists** ('05).

1. Emblem

AA1-06-012

2.

2. Break In

3.

4.

3. Festival-1 4. Festival-2

5. The Trap 6. Taking Shelter from the Rain 7. Bilking

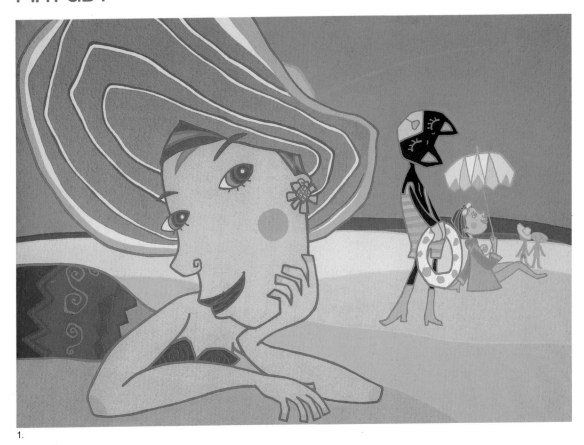

1.

Tsugumi YOSHIZAWA

E-mail: tsugumi_yoshizawa@ARTas1.com
URL: http://www.ARTas1.com/info/tsugumi_yoshizawa

skill: **W** ☐ **O** ☐ **A** ☑ **P** ☐ **C** ☑ **D** ☑

Inherent in all of Ms. Yoshizawa's works is a lyrical playfulness and direct engagement. Her cheerful characters seem to look at the viewers and invite them into the picture. Exhibited nationwide and introduced on TV programs, her illustrations have garnered her a greater reputation with each passing year. Ms. Yoshizawa's next goal is to jump into the fields of large murals, children's books, and product design. She is a co-founder of a creative firm based in Tokyo.

CLIENTS

Nikkei Business Publishing, Takara, Kodansha, Nippon Television Network, Benesse, The Daiei, and more...

AWARDS & SHOWS

Japan Graphic Exhibition Awards, Illustration CHOICE Prize, and more...
Selected exhibitions at Gallery Sai (Tokyo) **Small Framed Pictures**; Shinjuku My City (Tokyo) **Tsugumi Yoshizawa Exhibition**; Tokyo Broadcasting System **Hanamaru Market**; Aoyama Pinpoint Gallery (Tokyo). Ms. Yoshizawa has participated in many group shows as well.

1. At the Beach

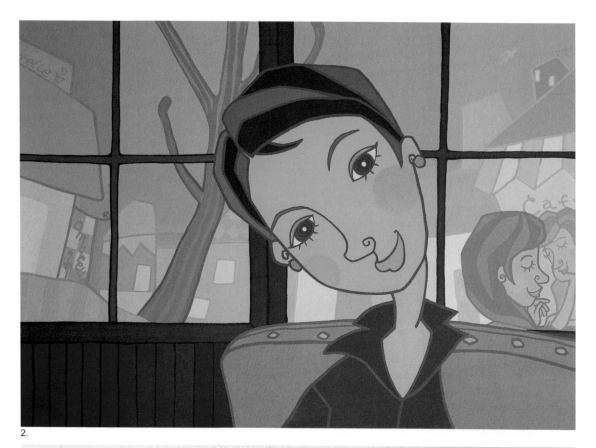

2.

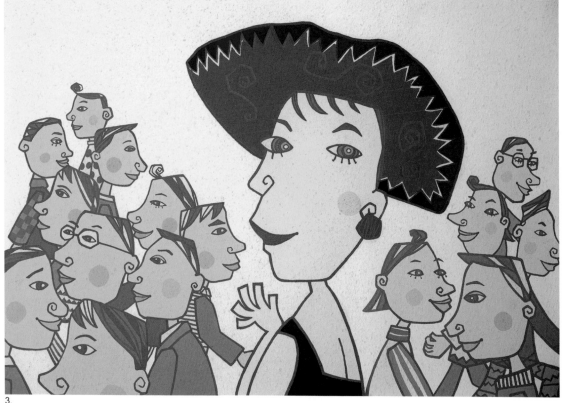

3.

2. Café 3. The Woman in the Hat.

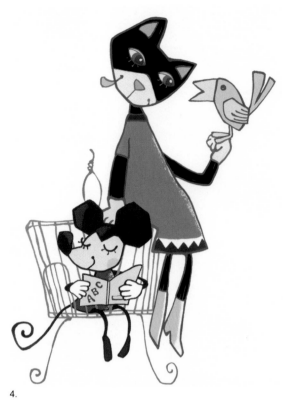

4.

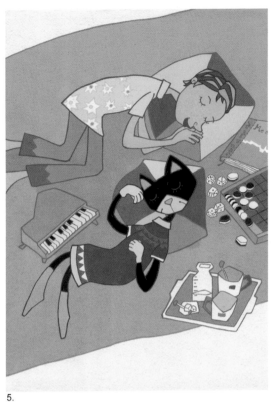

5.

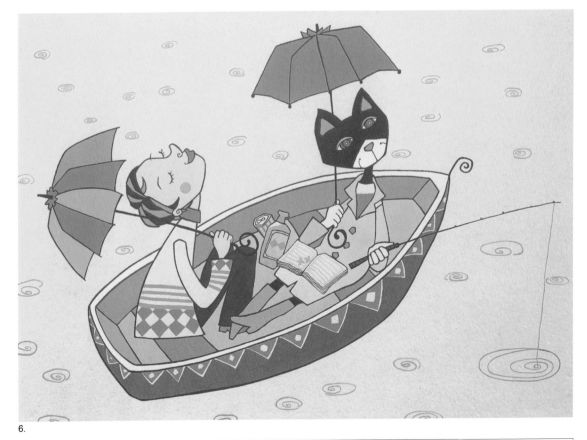

6.

4. Hungry Pals 5. A Nap at the Park 6. A Pretty Day

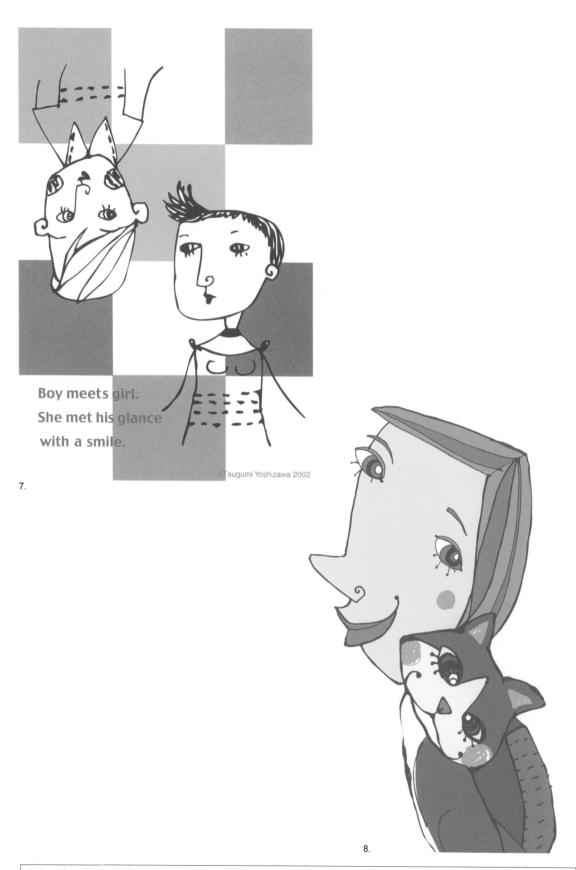

Boy meets girl.
She met his glance
with a smile.

© Tsugumi Yoshizawa 2002

7.

8.

7. Boy Meets Girl 8. Hinata Kitty and Girl

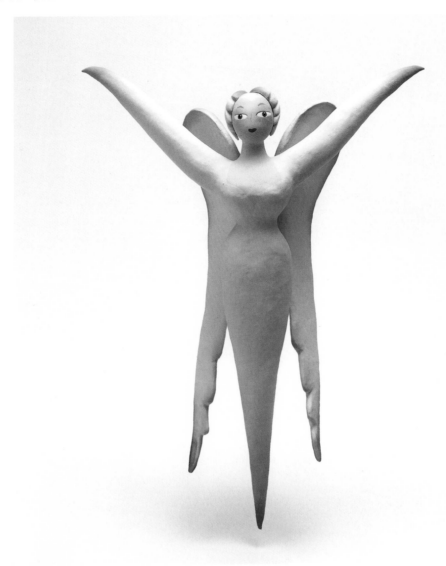

1.

Yaeo Ookubo

E-mail: yaeo_ookubo@ARTas1.com
URL: http://www.ARTas1.com/info/yaeo_ookubo

skill: **3-dimensional**

Design B.A., Tama Art University, Tokyo

With her humorous figures, Ms. Ookubo's art has gained a broad range of fans from children to adults. She works in print media, but her three-dimensional illustrations vibrantly animate the two-dimensional realm. Casting with styrofoam and molding in paper clay, she builds the foundations of her characters, and then adds colors in acrylic on the figures to provide an eye-catching finish.

CLIENTS
Hitachi, Victor Company of Japan, Mazda, Ricoh Japan, NTT Group, Kanebo, Sumitomo Mitsui Banking, Benesse, Gakken, Shufu-To-Seikatsusha, Sekai Bunka Publishing, Japan Broadcast publishing, and many more…

1. Fairy

AA1-06-014

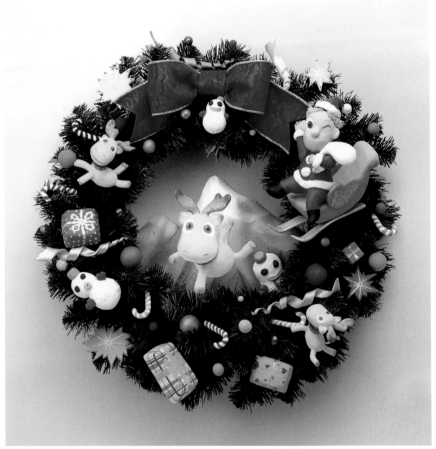

2.

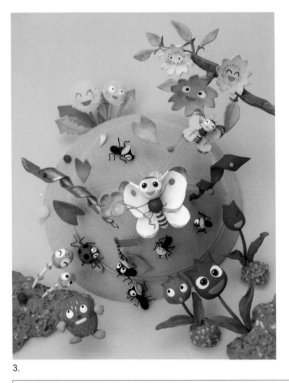

3.

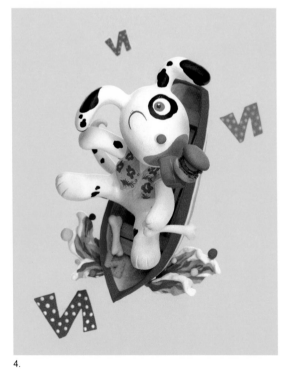

4.

2. Christmas Wreath　　3. Spring　　4. Wonderful Boat

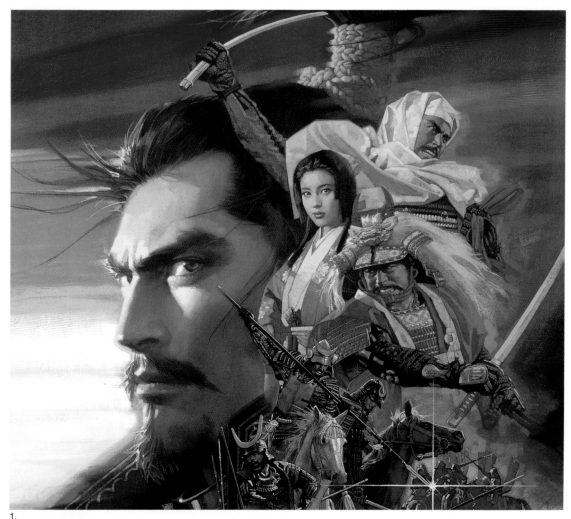

1.

Tsuyoshi NAGANO

E-mail: tsuyoshi_nagano@ARTas1.com
URL: http://www.ARTas1.com/info/tsuyoshi_nagano

skill: **W**☐ **O**☑ **A**☐ **P**☐ **C**☐ **D**☐

B.F.A., Nihon University College of Art, Tokyo

Among die-hard fans of **Star Wars**, Mr. Nagano has gained celebrity for the covers he created for the Japanese spin-off novels. Mr. Nagano's gigantic paintings have a dominating presence and artistic luxury. Although his top-notch skills are arguably unparalleled, his modesty only permits him to say, "It is crucial to have great rivals who are talented to keep me motivated." Maintaining his passion for art and cementing his interest in his subjects are equally important for his creations. "In the future, I would like to do a Western history series and would like to work on more movie posters, despite the fact that the current trend is more toward using photos nowadays," says Mr. Nagano. Member of **the Society of Illustrators** (NY) and **the Japan Publication Artist League**.

CLIENTS
Covers: Lucas Books and Sony Magazines **Star Wars** Japanese spin-off publications; Sekai Bunka Publishing **Sanguozhi (Three Kingdoms Saga)**; and many more... **Posters and Illustrations:** KOEI PC/online game series of **Nobunaka's Ambition** and **Romance of the Three Kingdoms**; Toho movie **Godzilla, Mothra and King Ghidorah:**

1. Nobunaga's Ambition

AA1-06-015

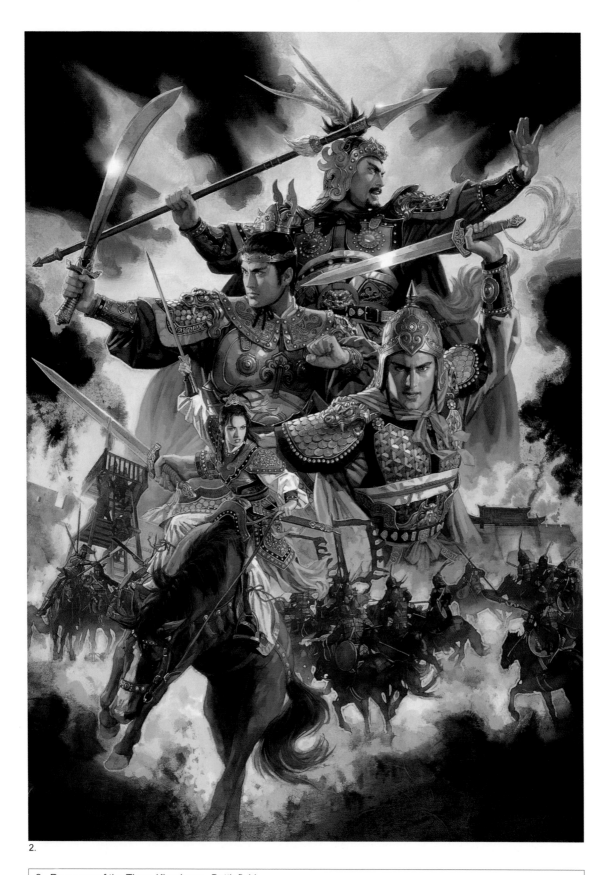

2.

2. Romance of the Three Kingdoms - Battlefield

3.

3. Gods and Goddesses of the World

© 2006 Tsuyoshi Nagano

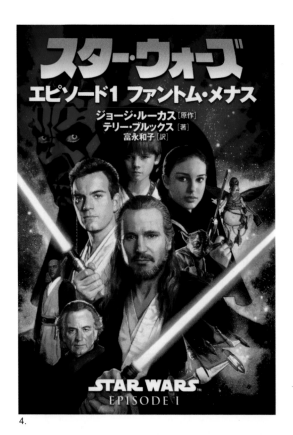

4.

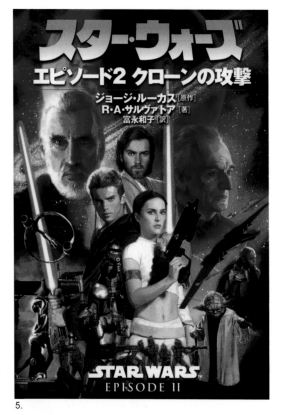

5.

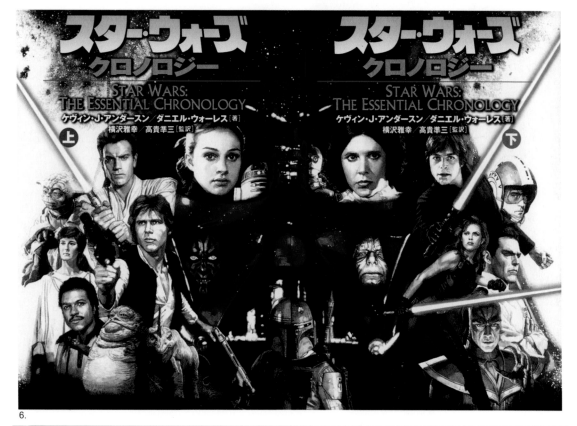

6.

1.

Shigehisa KITATANI

E-mail: shigehisa_kitatani@ARTas1.com
URL: http://www.ARTas1.com/info/shigehisa_kitatani

skill: **W** ☑ **O** ☐ **A** ☐ **P** ☐ **C** ☐ **D** ☑

Design B.A., Aichi Prefectural University of Fine Arts and Music

Since leaving the largest design production house in Japan (**Nippon Design Center**), Mr. Kitatani has freelanced for several decades and has had a great impact on the industry. He is well known for his humorous animated clips for TV commercials as well as his editorial and print works. Mr. Kitatani always begins his creative process by drawing delicately with a glass pen on paper before he transfers his creations to the digital realm. He is a member of **the Tokyo Illustrators Society**.

CLIENTS
Dentsu, McCann Erickson Japan, Panasonic, Shiseido, Diners Club International (Citi Cards Japan), Suntory, The Body Shop Japan, Hakuhodo, ADK, Japan Broadcasting Corporation (NHK), and many more…

AWARDS & SHOWS
Aoyama Pinpoint Gallery (Tokyo) **Shigehisa Kitatani: Original Prints**; Museum für Kunst und Gewerbe Hamburg; Marunouchi Café (Tokyo) **12 Days In New York**; Maison D'art **Shigehisa Kitatani: Joyeux Noel**; Aoyama Pinpoint Gallery **Shigehisa Kitatani: Etching Exhibition**; Vente Museum (Tokyo); Aoyama Pinpoint Gallery **Shigehisa Kitatani: Lithograph Exhibition**; and more…

1. The Conductor

AA1-06-016

2.

3.

2. London 3. Walking the Dogs

4. Original Print A 5. Original Print B

6.

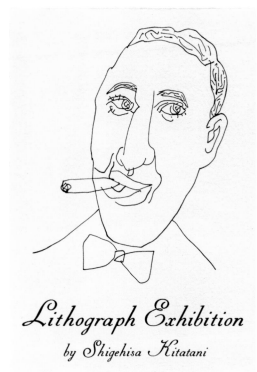

Lithograph Exhibition
by Shigehisa Kitatani

7.

8.

6. Original Print C 7. Poster for Solo Show 8. Original Print D

1.

DAVAKAN

E-mail: davakan@ARTas1.com
URL: http://www.ARTas1.com/info/davakan

skill: **W**☐ **O**☐ **A**☐ **P**☐ **C**☑ **D**☑

Design B.A., Osaka University of Arts

"I create my characters and *foster* them; infusing them with a living aura so that my characters shine, not only in magazines but also in animation and on TV. They evolve much like TV talents and movie stars do." The world of Mr. DAVAKAN conveys a sense of fun and an imaginative reality that always features his lively star-creatures. One of his popular characters, **Pink-hippo**, is a gorgeous but mischievous hippopotamus that is poised and ready to conquer the hearts of America.

CLIENTS
Poster illustrations: NEC Corporation, Japan Broadcasting Corporation (NHK), Mizuho Financial Group, and many more... **Animations:** Fukushima Central Television **Fukushima Minwa-Kan (folk tale)** and many more... **Magazine / Book Illustrations and Publications:** Sekai Bunka Publishing **Oekaki (Drawing) Logic Quarterly** (cover); Benesse **Kodomo (Kids) Challenge Step Monthly**; Ritto Music **CD – ROM Magazine Monthly** (cover); **DAVAKAN** artist book **Dennou Rakuen (Cyber Paradise)**; and many more...

AWARDS & SHOWS
Solo shows at Dentsu Ad Gallery (Tokyo), Aoyama Pinpoint Gallery (Tokyo), and many more...

1. Characters

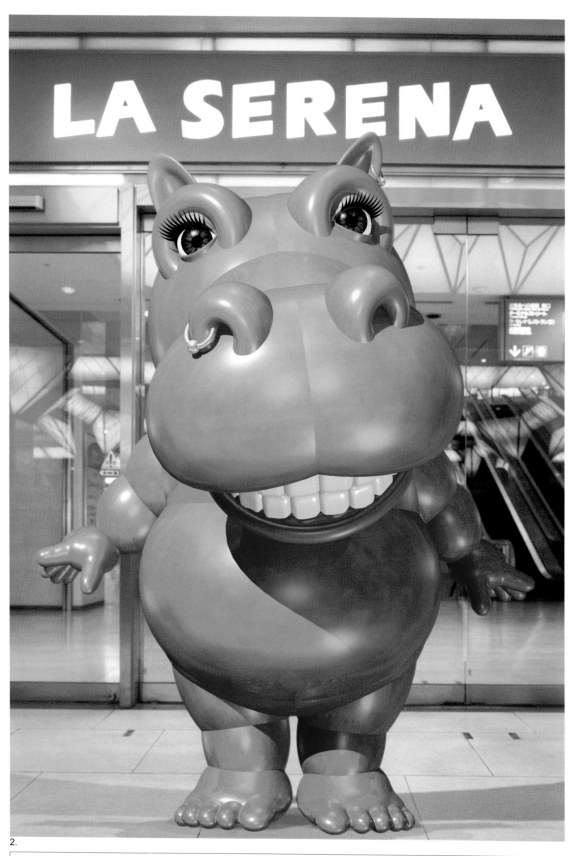

2.

2. Pink-hippo

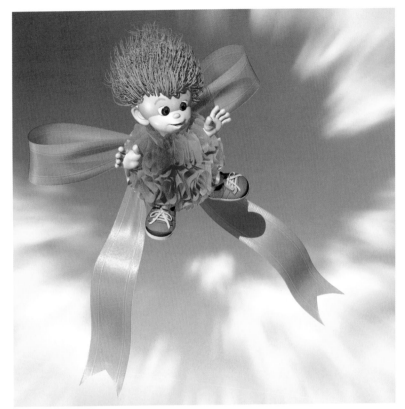

3.

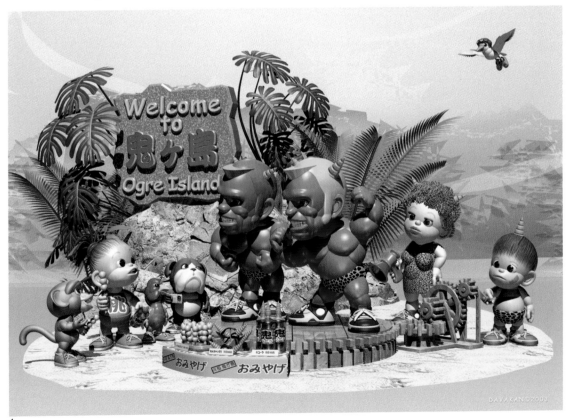

4.

3. Ribbon Fly 4. Welcome to Ogre Island

5.

6.

5. The Party 6. Harry

1.

Yume-hime / Dava Mayumi

E-mail: yume_hime@ARTas1.com
URL: http://www.ARTas1.com/info/yume_hime

skill: **W**☐ **O**☐ **A**☐ **P**☐ **C**☑ **D**☑

Design B.A., Tama Art University, Tokyo

Like her pseudonym (*Yume-hime = Princess of Dreams*), Ms Dava's world is infused with magic. The cultural art forms of silhouettes and magic lanterns from Bali and Okinawa are sources of inspiration for her. When she depicts Eastern fantasy and folk tales, she researches their historical background and the mannerisms of daily life. "All aspects of *yohaku* (blank space), background, color, and typography have to work all together in order to make perfectly intriguing compositions."

CLIENTS
Cannon, Adobe Systems, Kodansha, Shueisha, Tokuma Shoten Publishing, Fukushima Central Television, Mainichi Communications, Impress, and many more…

AWARDS & SHOWS
Awarded Japan CG Grand Prix Honorable Mention. Selected solo shows and group shows at Space ('02, Tokyo); Station Gallery in Matsuyama **DAVAKAN & Dava Mayumi** ('98); Aoyama Pinpoint Gallery (Tokyo) **Yume-hime: Oriental Fruits** ('95) and **Otohime Legend**; and many more…

1. Yume-hime

AA1-06-018

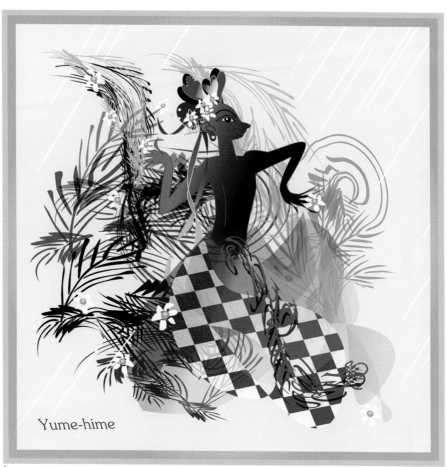

Yume-hime

2.

3.

2. Scarf 3. Love

1.

KUNTA

E-mail: kunta@ARTas1.com
URL: http://www.ARTas1.com/info/kunta

skill: **W**☐ **O**☐ **A**☐ **P**☐ **C**☑ **D**☑
Other (Airbrush)

Self-taught, Mr. KUNTA explores daily social life and societal ideals through animal figures. Achieving a gentle warm-heartedness in his often communal scenes, he works in many different mediums such as airbrush, paper cutout, drawing, and digital. The clean lines and attention to detail in his pieces are very recognizable. Member of *the Society of Illustrators* (NY), *the Japan Graphic Designers Association*, and *the Tokyo Illustrators Society*.

CLIENTS
Visual promotions, product planning: Bridgestone, HITACHI, Honda Verno Shintokyo, Unilever Japan, Tokyo Dome, and many more… **Covers and Illustrations:** Shueisha, Kodansha, Recruit and many more…
Publications: Artist book *PiPoRiPaRa WORLD*.

AWARDS & SHOWS
New York Museum of American Illustration - Gallery 1 *Thirteen* ('96); The Society of Illustrators (NY) Member's Gallery *Three Japanese Members* ('99); Tokyo Illustrators Society Exhibition in France; Japan – Korea Cultural Exchange Hall in Seoul *Japan – Korea Group Exhibition*; Oji Paper Gallery (Tokyo); Mitsumura Art Plaza (Tokyo); International Design Center in Nagoya; and many more…

1. A Happy Night

© 2006 KUNTA

AA1-06-019

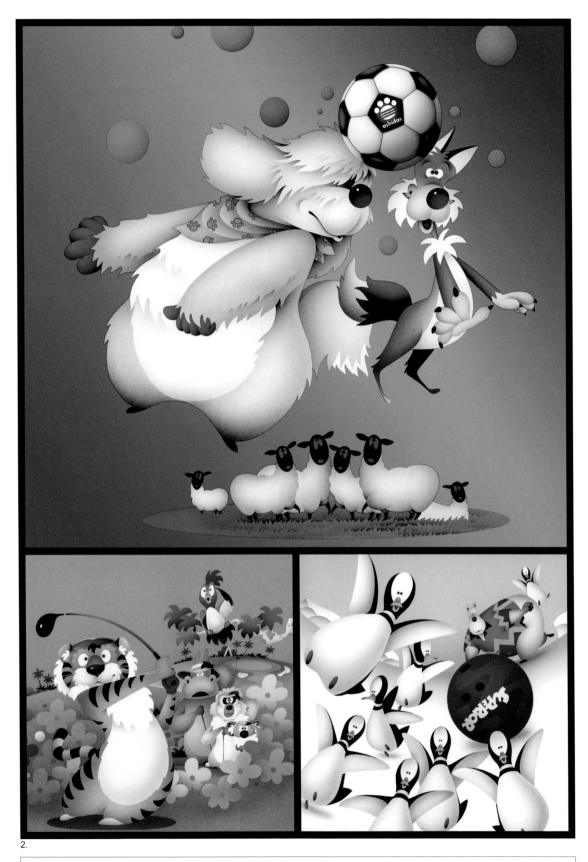

2.

2. We Love Sports

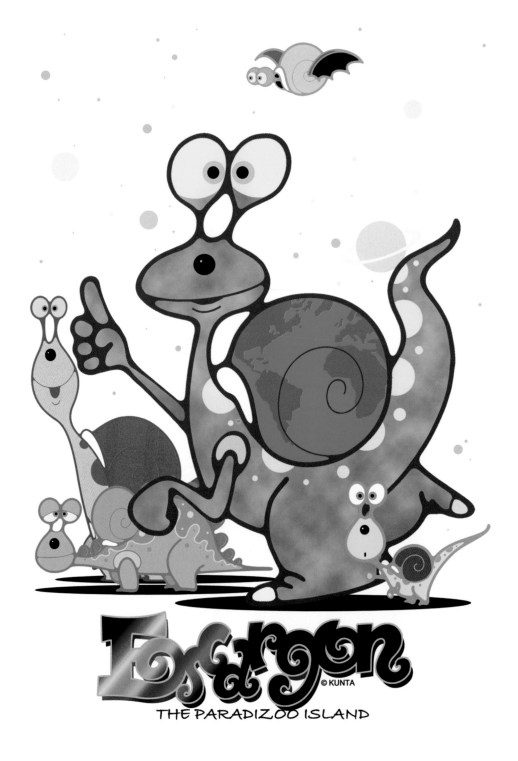

THE PARADIZOO ISLAND

3.

3. ESCARGON

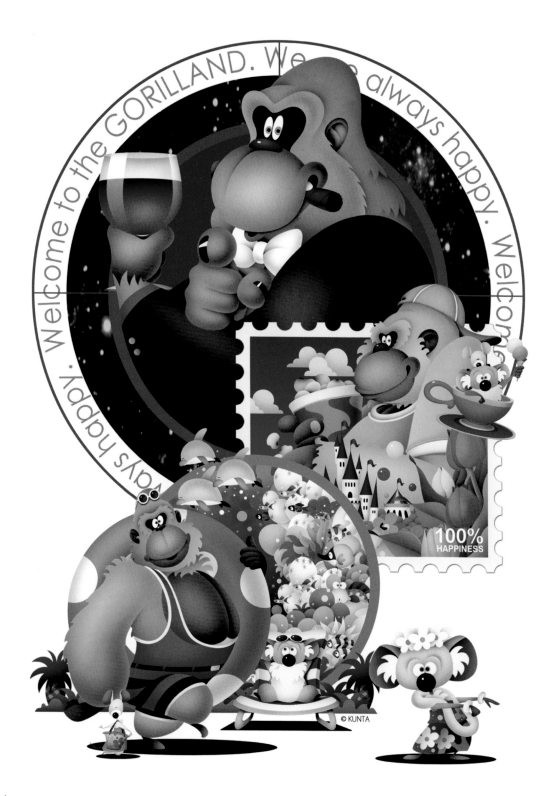

Welcome to the GORILLAND. We are always happy. Welcome

100%
HAPPINESS

© KUNTA

4.

4. GORILLAND

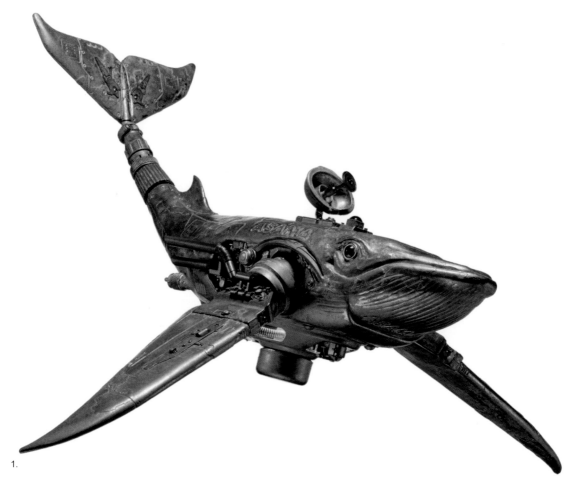

1.

Hitoshi MIURA

E-mail: hitoshi_miura@ARTas1.com
URL: http://www.ARTas1.com/info/hitoshi_miura

skill: **W**☐ **O**☐ **A**☐ **P**☐ **C**☑ **D**☑
Other (3-dimensional)

Fascinated by the irresistible beauty of found objects, Mr. Miura refasions weathered materials into art. Created in collaboration with photographers and printers, his stunning three-dimensional illustrations combine resurrected waste with bold visual and textural statements. Mr. Miura's works of art have been exhibited at several shows world-wide. Member of **the Japan Graphic Association, Inc**.

CLIENTS
Konica Minolta Japan, Hitachi, Nissan Graphic Arts, Aichi Toyota, Kodansha, Shueisha, Kadokawa Haruki Corp., and many more...

AWARDS & SHOWS
3-Dimensional Art Directors & Illustrators Awards Show (U.S.A.) Best of Show Award, Gold Award, Silver Award, Bronze Award; Busan International Design Festival; International Print Triennial – Krakow (Poland) Honorary Distinction; International Poster Triennial in Moscow First Grade; The Art Directors Club (NY) 6th and 7th Annual Awards; entrances into the Annual Exhibition of The Society of Illustrators (NY) ('99, '98, '97, '96, and '95); and many more... Selected for exhibition at **Art of Mickey Mouse**, and many more...

1. Sky Whale

© 2006 Hitoshi Miura

AA1-06-020

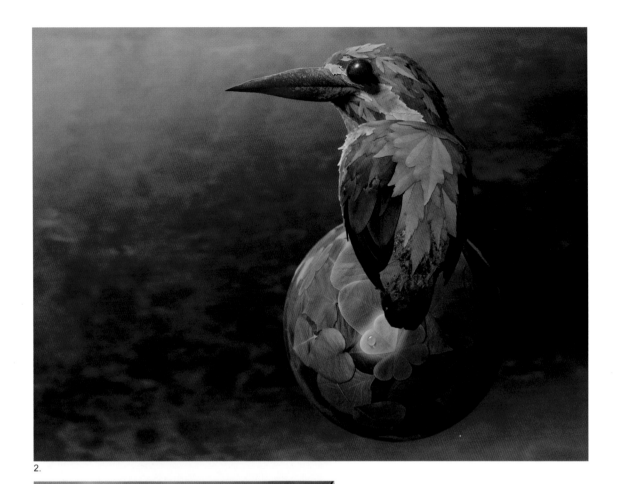

2.

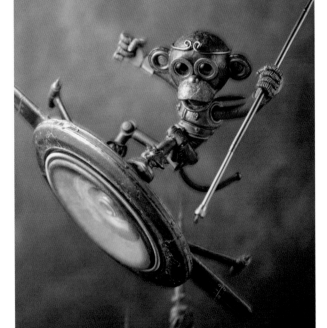

3.

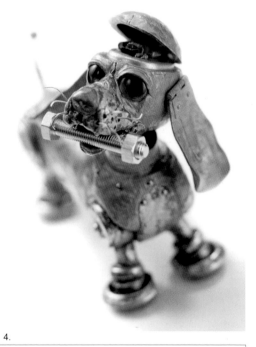

4.

2. The Nature Force Star 3. Sun Wu Kong 4. Cyber dog MIMI

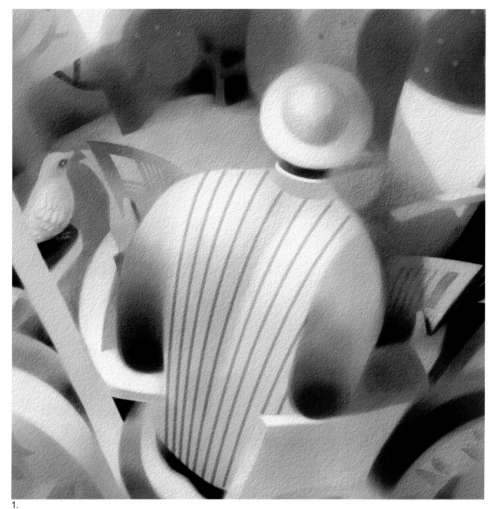

1.

Hiromitsu YOKOTA

E-mail: hiromitsu_yokota@ARTas1.com
URL: http://www.ARTas1.com/info/hiromitsu_yokota

skill: **W**☐ **O**☐ **A**☐ **P**☐ **C**☑ **D**☐

Fine Arts B.A., Musashino Art University, Tokyo

Mr. Yokota creates images that capture "blissful seasons," instilling them with the spirit of everyday life and the idea of "living in the present." His illustrations are created and processed digitally in order to render a subtle play of light and color gradation, and lending them the appearance of hand-drawn pastels. Mr. Yokota's works have appeared in numerous books, magazines, and calendars. His expertise in making piezo graph prints is also highly acclaimed. Member of **the Society of Illustrators** (NY).

CLIENTS
Visa Japan, Asahi Shimbun Newspaper, Oji Paper, and many more...

AWARDS & SHOWS
Annual Entries to the Society of Illustrators (NY). One-man exhibitions at Oji Paper Gallery Ginza every year since 1994. Museum of American Illustration – Gallery 1 **NIPPON** ('03), Museum of American Illustration – Member's Gallery **Three Japanese Members** ('99), Museum of American Illustration – Galley 1 **Thirteen** ('96), Dazzle Aoyama, and many more...

1. The Newspaper

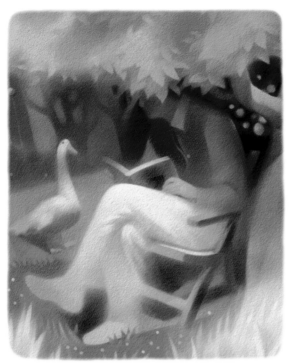

2.

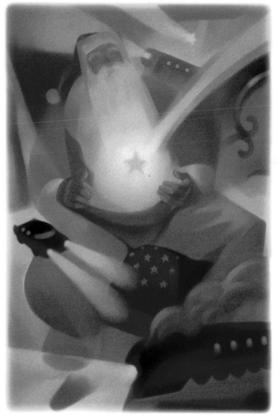

3.

2. Book Week 3. Magical Christmas!

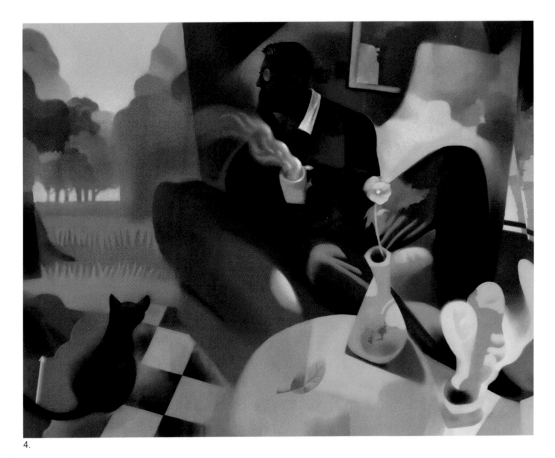

4.

4. Fragrance

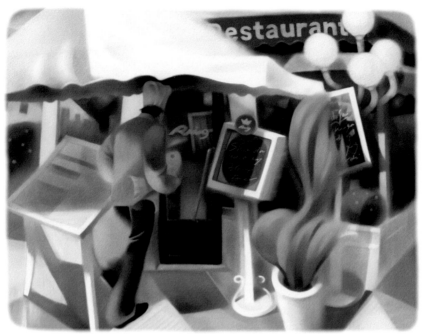

5.

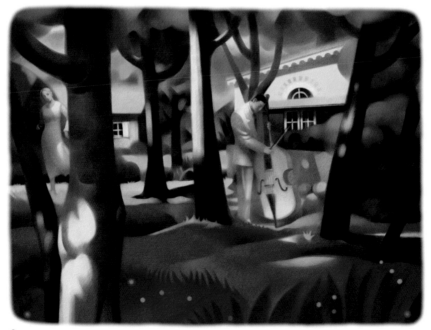

6.

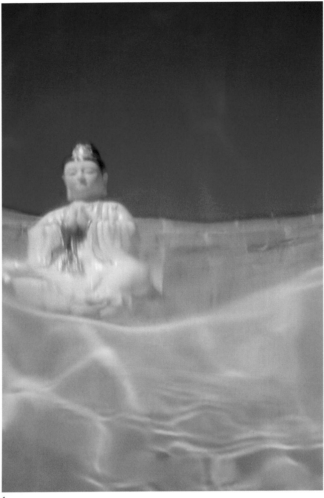

1.

Kimiyuki TSUJI

E-mail: kimiyuki_tsuji@ARTas1.com
URL: http://www.ARTas1.com/info/kimiyuki_tsuji skill: **Other** (photograph,installation)

Kimi's works capture the rippling play of light and water in swimming pools. Exploring the dimensions of water, light, and time, his installations submerge his audiences in fluid atmospheres. "I hope audiences can feel the strength, warmth, and tenderness of the water when experiencing my art," says Mr. Tsuji. He also aspires to produce site-specific installations in hotels, bars, and cafés throughout the world, where the public can be energized by his works.

CLIENTS
Art Print Japan, and more... Mr. Tsuji has worked on stage design for several theatrical shows.

AWARDS & SHOWS
Solo shows at ATELIER K (Yokohama) *Alive Blue*; WAVES (Kanagawa) *Blue Heaven*; Iwasaki Museum (Yokohama) *Innocent Blue* (sponsored by KODAK & Kirin Brewery); Graphic Station (Tokyo) *Silent Blue*; Yokohama International School (art collaboration event); and many more...

1. God's Blue

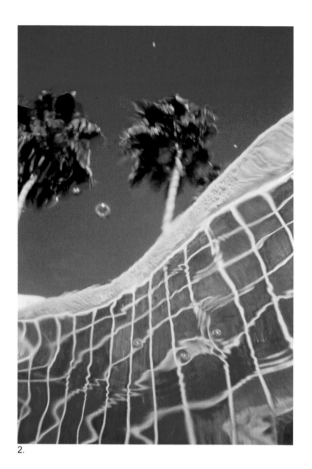

2.

3.

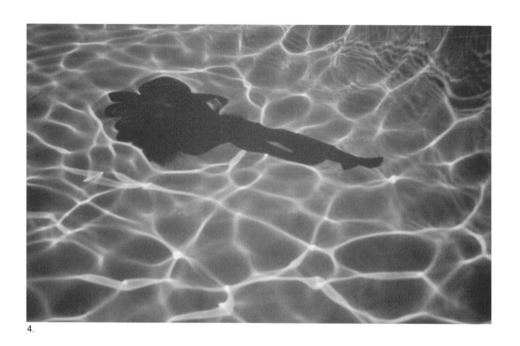

4.

2. Blue Sky 3. Blue Bubbles 4. Body Blue

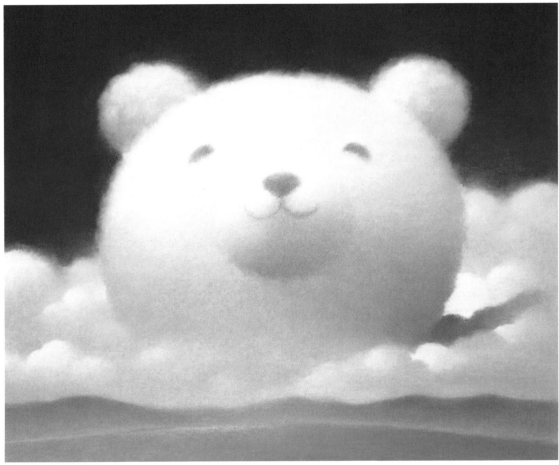

1.

Hiroshi WATANABE

E-mail: hiroshi_watanabe@ARTas1.com
URL: http://www.ARTas1.com/info/hiroshi_watanabe

skill: **W**☐ **O**☐ **A**☐ **P**☑ **C**☐ **D**☐

Design B.A., Osaka University of Arts

Mr. Watanabe's blue hues are extraordinary. In his own words, "Watanabe Blue is like a blue sky that goes on forever, and an unlimited expanse of blue ocean. It holds enormous power." Pastels are not just tools for him, but a profound material with which to describe his feelings on paper. Audiences adore his characters for their warmth and universality. Mr. Watanabe's works straddle genres, appearing in media ranging from advertising, magazines, and CD covers to illustrated children's books. He is a member of **the Society of Illustrators** (NY) and **the Tokyo Illustrators Society**.

CLIENTS
Sony Music Direct, BMG Japan, ITOCHU Corp., and many more…

AWARDS & SHOWS
Exhibited at The Art Directors Club (NY) ('88, '91, '92); selected for Annual Exhibition at The Society of Illustrators (NY) ('96, '05); Industrial Advertising Association Japan Award; Japan Packaging Association Award; Illustration The CHOICE Grand Prize; and many more… Solo shows in 2006 have already been scheduled throughout Japan and China (Shanghai).

1. Big White Bear's Smiling Face

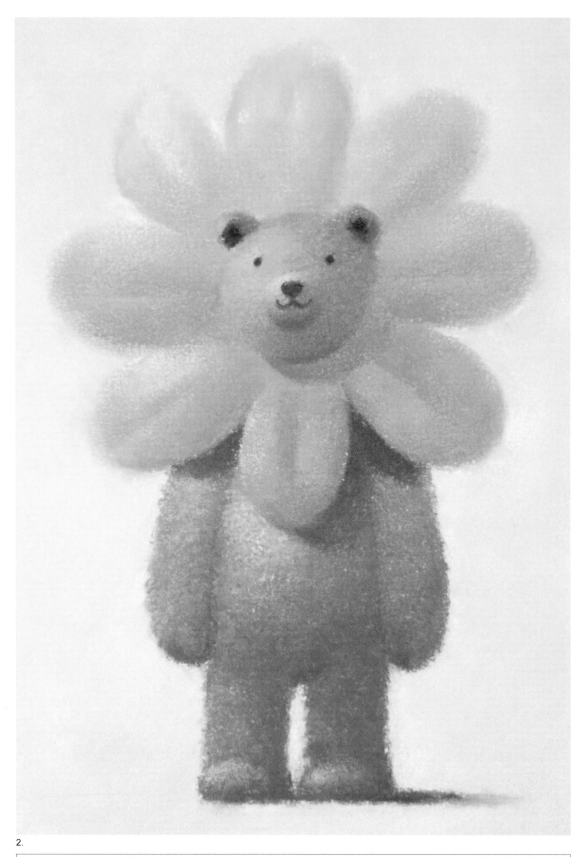

2.

2. Yellow Flower Bear

3.

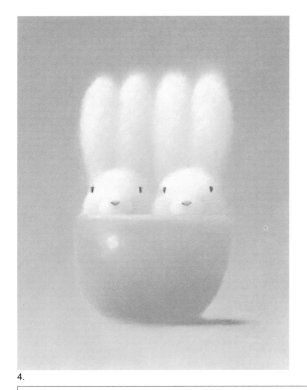

4.

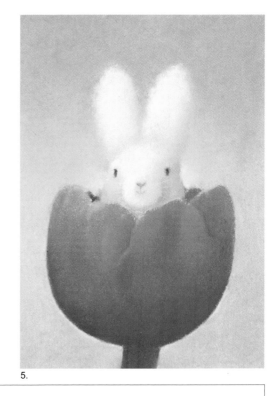

5.

3. The Cup of Flowers 4. Always Together 5. Coming of Spring

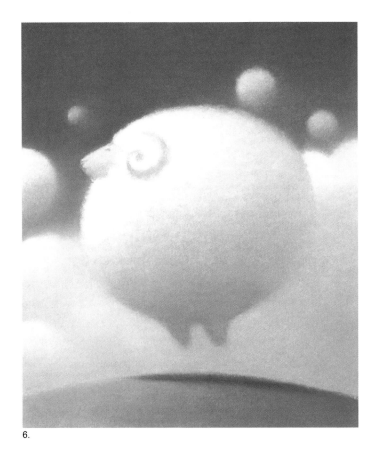

6.

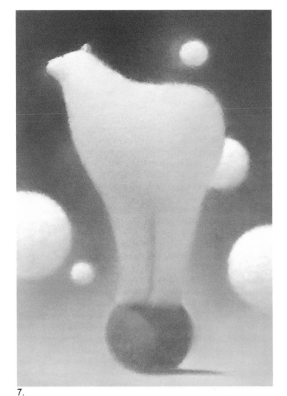

7.

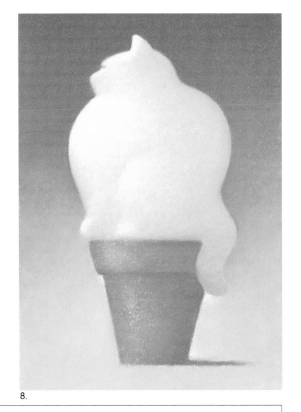

8.

6. A Spring Wind 7. A Soft Feeling 8. The Soft Cat

© 2006 Hiroshi Watanabe

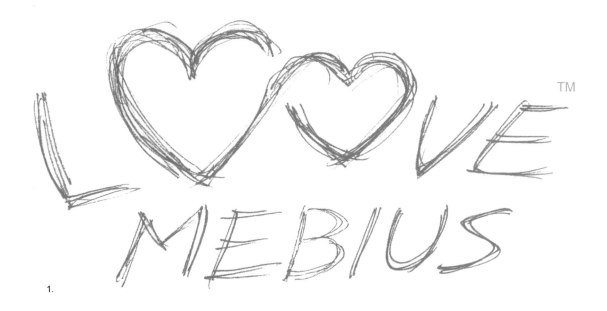

1.

PEACEMEBIUS

HIRO-SHI

E-mail: hiro_shi@ARTas1.com
URL: http://www.ARTas1.com/info/hiro_shi

skill: **W**☐ **O**☐ **A**☐ **P**☐ **C**☐ **D**☑

B.F.A., The Cooper Union School of Art, New York, NY

Highly regarded as an art director in New York and Tokyo, for the past decade Mr. HIRO-SHI has collaborated with several high-profile international clients from all industries. Recently, he has also embarked on a successful career as a visual artist. "There is no need to hold on to a specific medium or material, no need to categorize styles of visual art, much less the method of making it. No matter what it takes to make it, photographs or illustrations, visual art should communicate," he says. With this philosophy, Mr. HIRO-SHI wants to *craft* visual art rather than design it. It is crucial for him to create visual art with a strong expression because his goal is to have his audiences *feel* the works, and remember that feeling. He knows that his visual arts will eventually turn into commoditized properties, but he still "strives to craft the human state of mind."

AWARDS & SHOWS
Numerous international advertising awards.

1. LOVEMEBIUS™ Logo

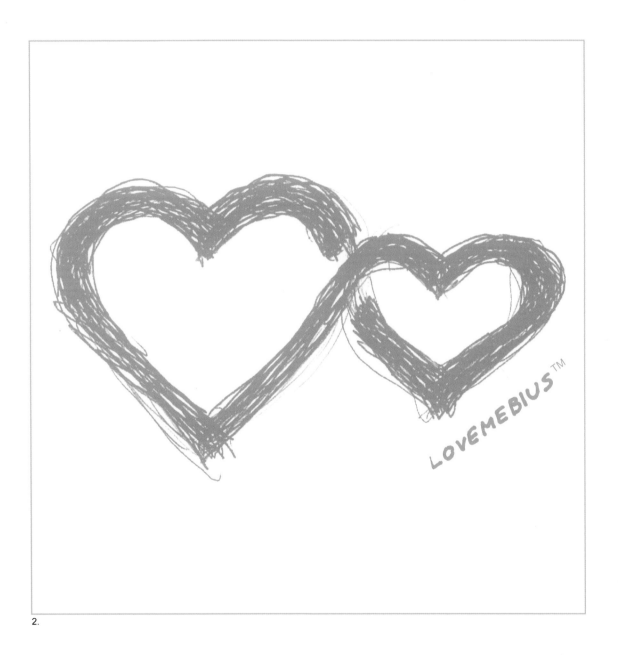

2.

2. LOVEMEBIUS™ Logo Mark

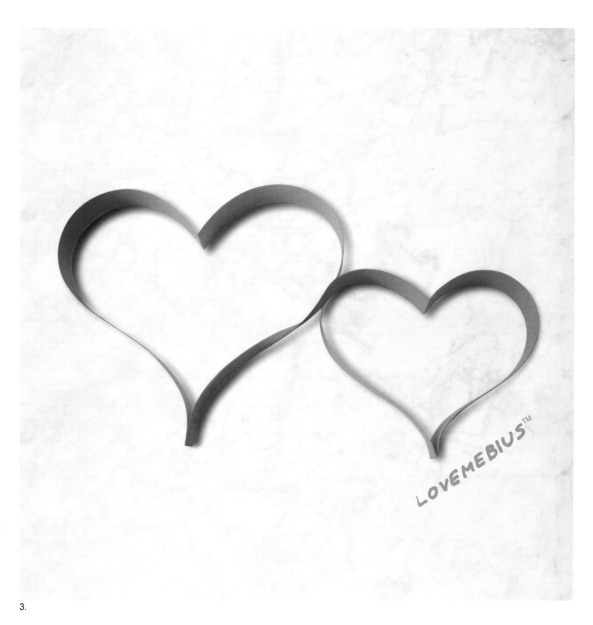

3.

3. LOVEMEBIUS™ 3-Dimensional

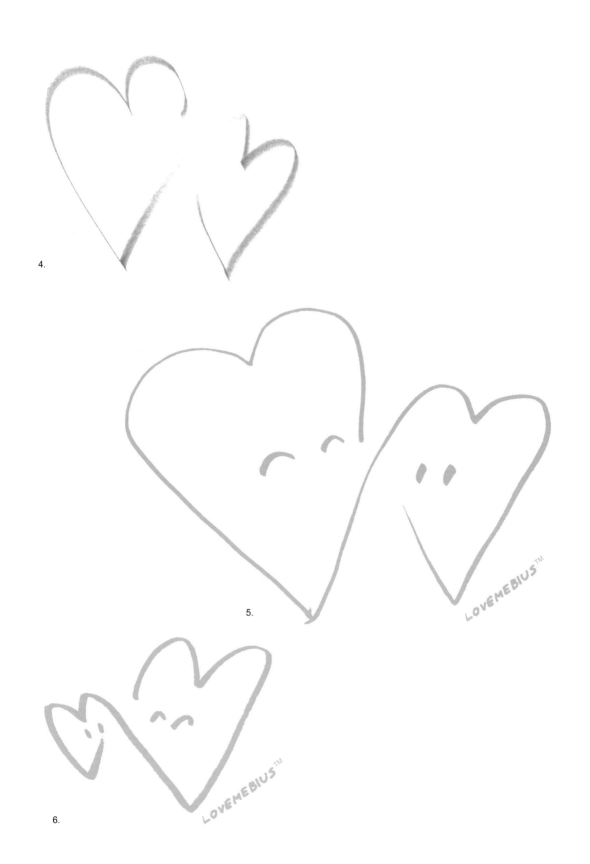

4.

5.

6.

4. LOVEMEBIUS™ One Stroke 5. LOVEMEBIUS™ Mark 6. LOVEMEBIUS™ Mark - from parent to offspring

© 2006 HIRO-SHI

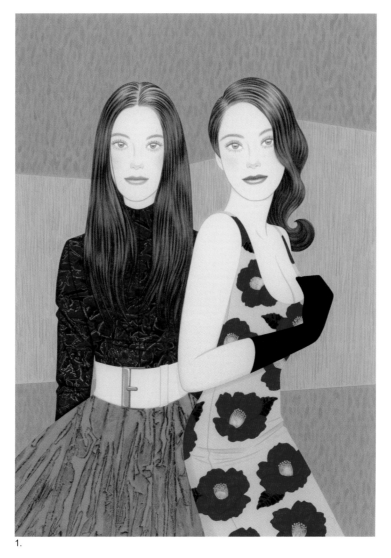

1.

Shinichi FUKUI

E-mail: shinichi_fukui@ARTas1.com
URL: http://www.ARTas1.com/info/shinichi_fukui

skill: **W**☑ **O**☐ **A**☑ **P**☐ **C**☐ **D**☑

"For me, truly professional illustrators are those who have a powerful artistic signature and can elevate any projects assigned by the client." Mr. Fukui applies the sensitivity of Japanese traditions into today's modes of expression, creating works that are distinctive for their technical virtuosity and conceptual skill. With an artistic practice propelled by ideas, technique, and then performance, Mr. Fukui explores themes of the future, seeking to imagine a better world, especially in terms of the relations between humans, nature, and the man-made world. He is a member of *the Tokyo Illustrators Society*.

CLIENTS
Sony Music Direct, BMG Japan, ITOCHU Corp., JR Tokai Agency, and many more…

AWARDS & SHOWS
Tokyo Art Directors Club Awards; Kodansha Advertising Award; Asahi Advertising Award; Illustration The CHOICE Awards for Excellence; and many more…

1. Two Beauties

AA1-06-025

2.

3.

2. Speed Star 3. In Her Room

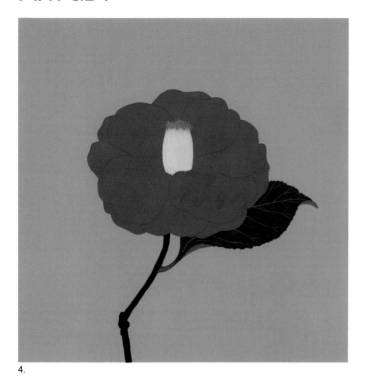

4.

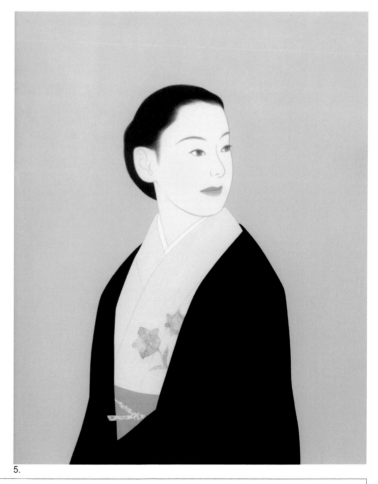

5.

4. Camelia 5. Black HAORI

6.

7.

8.

6. Short Haired 7. Nut-brown 8. Beginning of Summer

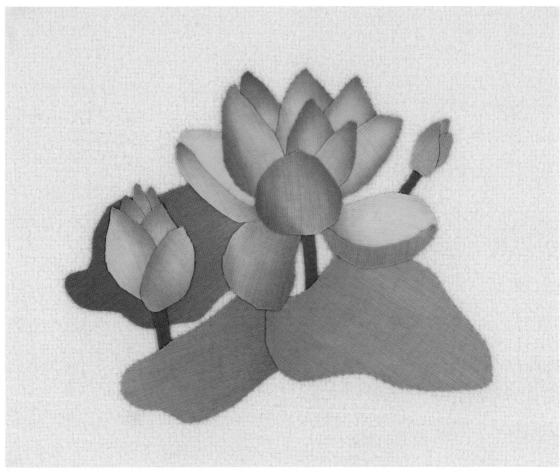

1.

Eri SAIKE

E-mail: eri_saike@ARTas1.com
URL: http://www.ARTas1.com/info/eri_saike

skill: **Other** (Textile design)

Design B.A., Tama Art University, Tokyo

Combining her professional experience in the fields of graphic design and apparel design, Ms. Saike investigates the artistic possibilities of fabric. Her collages are an assemblage of appliqué and computer generated images, transferred onto hand-woven, hand-dyed cloth. Her works can be called paintings, but they are in fact painted with fabric and accompanied by layers of appliqué that evoke a unique world. Ms. Saike enjoys studying the various color combinations in this world of hers, sometimes for years at a time.

AWARDS & SHOWS

Ms. Saike has been selected for several group shows.

1. The Lotus Bloom

AA1-06-026

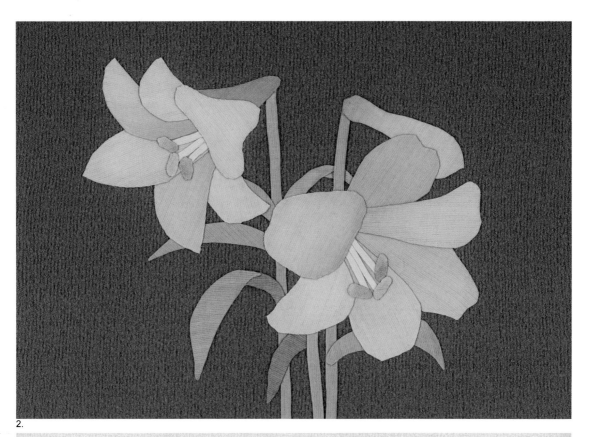

2.

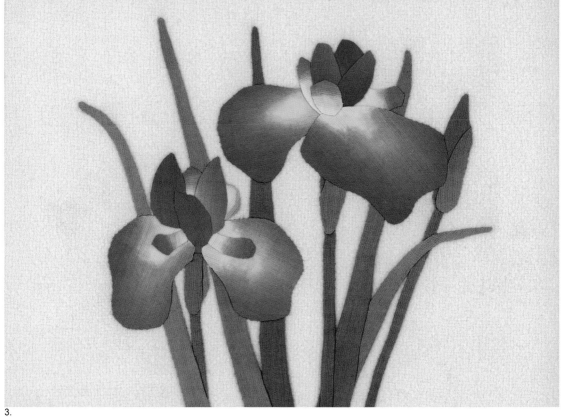

3.

2. Lily 3. Iris

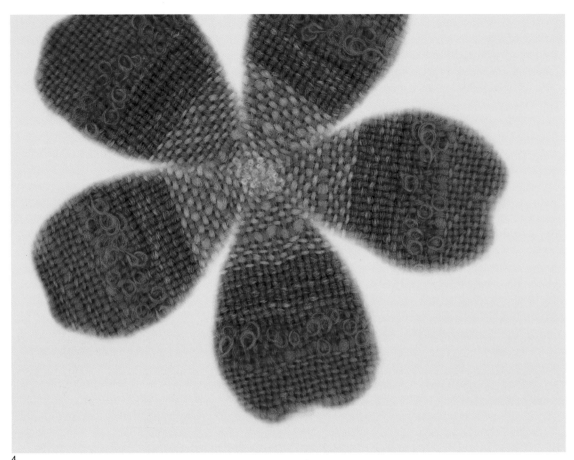

4.

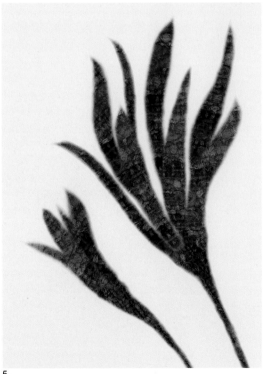

5.

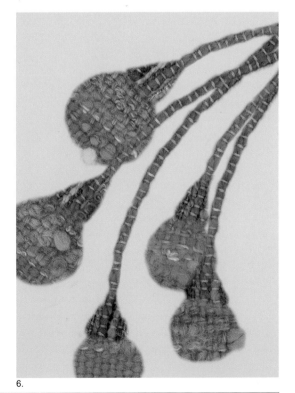

6.

4. Red Flower 5. Purple Flower 6. Orange Blossom Buds

7.

7. Various Weavings

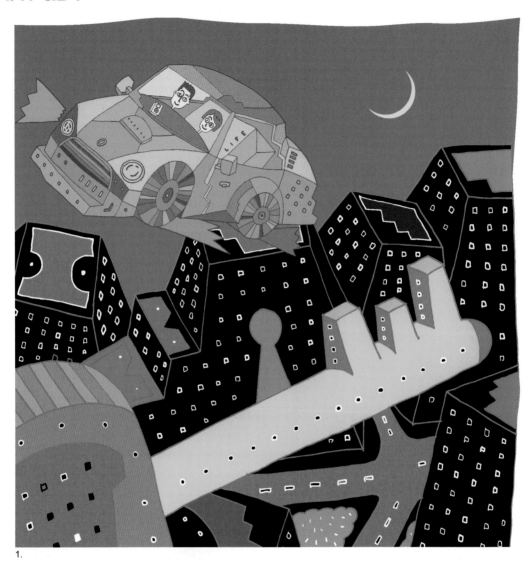

1.

Hal WATANABE

E-mail: hal_watanabe@ARTas1.com
URL: http://www.ARTas1.com/info/hal_watanabe

skill: **W** ☐ **O** ☐ **A** ☑ **P** ☑ **C** ☐ **D** ☑

Design B.A., Musashino Art University, Tokyo

Being free from technical rules and mundane theories of art is critical to Mr. Watanabe's creative process. A street scene with architecture is purposely delineated "out of perspective" and his geometric shapes are drawn organically, freehand. He finishes his works digitally, employing the computer as an essential tool in the same way that a painter uses pencils, brushes, and pallets. Mr. Watanabe gives his worlds individuality with a rhythm of colors and textures, and a harmony in composition.

CLIENTS
Covers, editorial illustrations and layout designs for major Japanese publishers including Gakken, Nihon Bunkyou Shuppan, Nippon Jitsugyo Publishing, Toyo Keizai, Gijutsu-Hyohron, and many more…

1. The Adventure

© 2006 HAL Watanabe

AA1-06-027

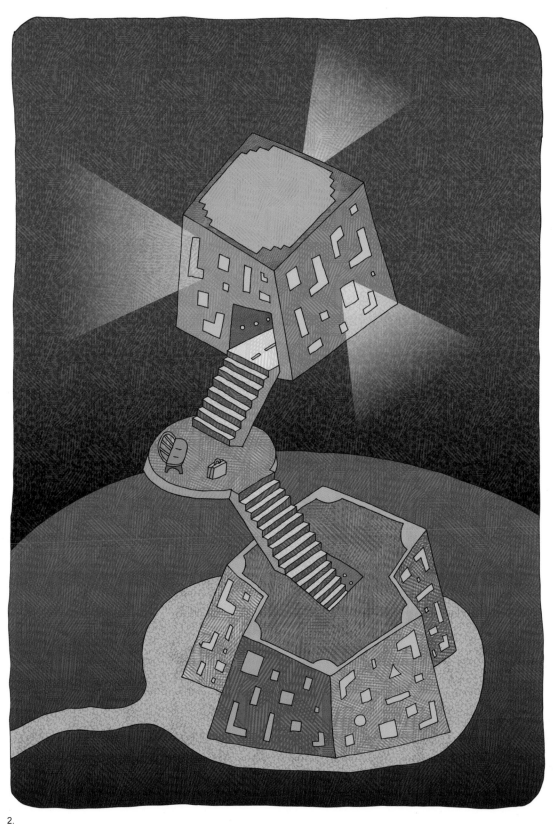

2.

2. The Watchman

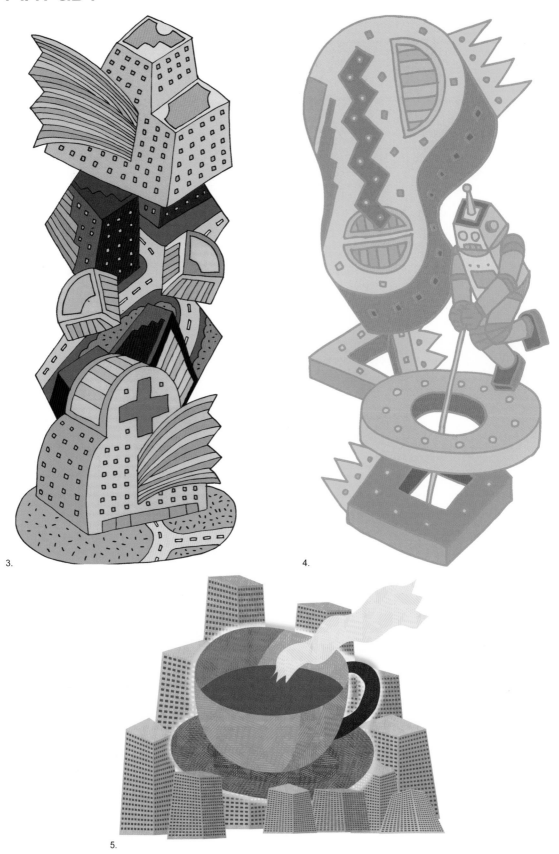

3.

4.

5.

3. The Deep Forest 4. The Afternoon of a Dream 5. Fragrance of the Moment

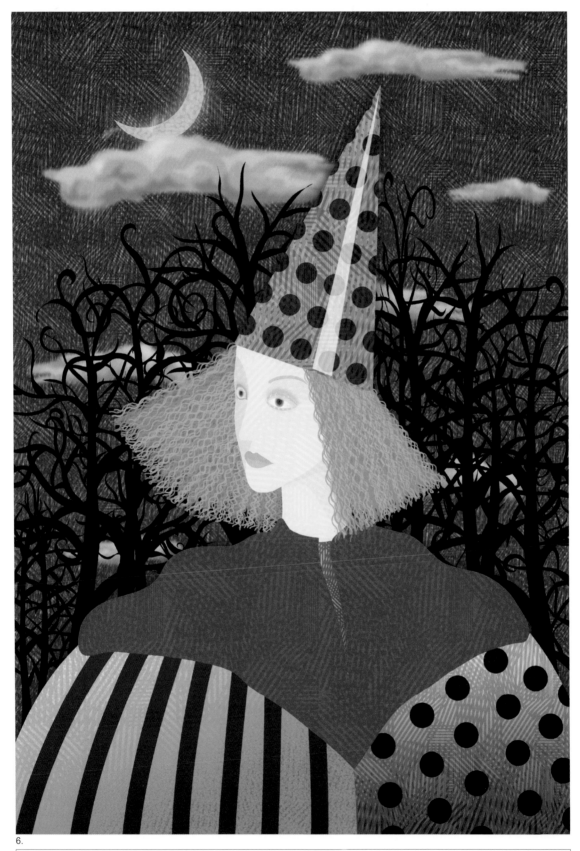

6.

6. Carnival

1.

Miyako NOMURA

E-mail: miyako_nomura@ARTas1.com
URL: http://www.ARTas1.com/info/miyako_nomura

skill: **W**☑ **O**☐ **A**☑ **P**☐ **C**☐ **D**☐

Design B.A., Tama Art University, Tokyo
Design M.A., Tokyo National University of Fine Arts and Music

Ms. Nomura's artworks represent indicate physical and metaphysical spaces of contemplation. In conjunction with a richness of hues and grace of forms, her abstract worlds explore unconventional pictorial signs. Her works have appeared in various promotional posters, prints, and publications. In the future, Ms. Nomura is looking forward to taking on the challenges of picture books, theatrical designs, and large installations. She is a member of **the Tokyo Illustrators Society**.

CLIENTS
The Windsor Hotel TOYA, JR Tokai Agency, Mainichi Communications, Takeo Paper Company, Kanou Shoujuan, and many more…

AWARDS & SHOWS
Illustration CHOICE Prize, and more… Exhibitions at The Tokyo Illustrators Society Creation Gallery G8 (Tokyo), YURINDO Gallery (Yokohama), and many more…

1. Span

2.

3.

2. Cue-Sound of Bamboo 3. Cue-Sound of Sea

4.

5.

4. Snaky 5. Enliven One's Spirit

6.

7.

6. Rainy 7. Downtown

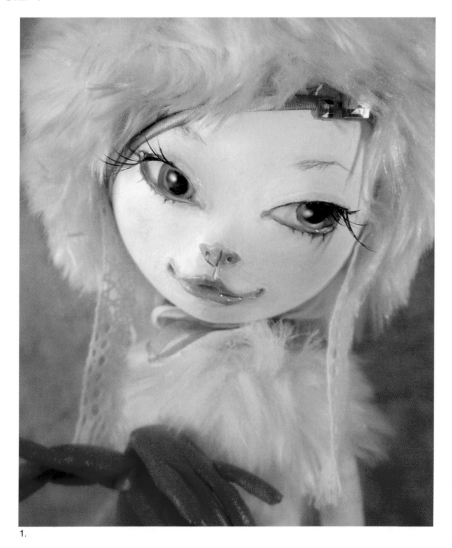

1.

Miwa SUGANUMA

E-mail: miwa_suganuma@ARTas1.com
URL: http://www.ARTas1.com/info/miwa_suganuma

skill: **W**☐ **O**☐ **A**☐ **P**☐ **C**☑ **D**☐
Other (3-dimensional)

B.F.A., Nagoya University of Arts

Quirky worlds made of unconventional materials are Ms. Suganuma's specialty. She works by trial and error to crystallize her ideas into a three-dimensional reality, choosing materials with appealing sculptural presence. Whether in the two-dimensional or three-dimensional realm, her illustrations promise to entertain audiences, and this she feels, is the primary goal of commercial illustration. Her works have appeared in various advertising campaigns and on television programs.

CLIENTS
Japan Broadcasting Corporation (NHK), Online Shop Mutow, Kintetsu Department store, Kikuchi Optometry, and many more...

AWARDS & SHOWS
She has joined in various selected group shows and annually participated in the Nagoya Illustrators Club Exhibition.

1. Joyeux Noel

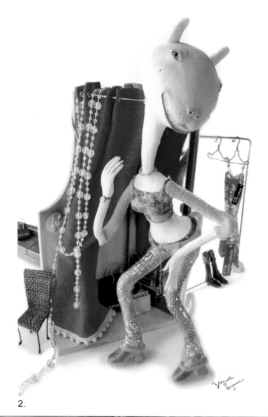

2.

3.

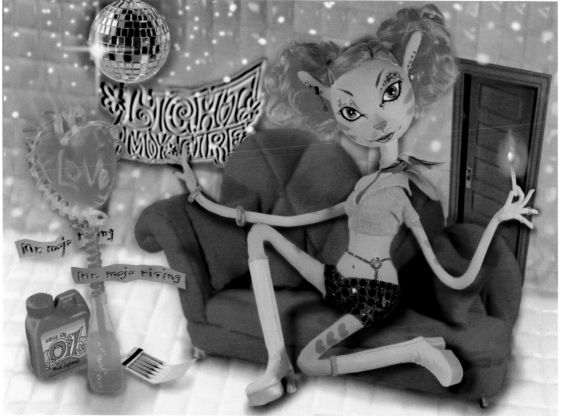

4.

2. The Fitting Room 3. Window Shopping 4. Light My Fire

1.

Kazuko TSUJI

E-mail: kazuko_tsuji@ARTas1.com
URL: http://www.ARTas1.com/info/kazuko_tsuji

skill: **W**☑ **O**☐ **A**☐ **P**☐ **C**☐ **D**☑

Kyoto Saga University of Arts Junior College

"I like to create a narrative world with my spontaneous lines. Whatever I illustrate I try to stay aware of the movement of the mind." Ms. Tsuji's vibrantly colored illustrations are inspired by memories from childhood, as well as people, animals, still lifes, plants, and almost anything has organic properties. Her works can be seen on various murals, posters, advertising campaigns, book covers, children's books, and CD covers. Ms. Tsuji also writes books and her latest popular publication focuses on Kabuki.

CLIENTS

Starbucks Coffee Japan (seasonal posters, mugs, tumblers), BMG Japan, Suntory Ladies Open, Marie Claire Japan (Kadokawa Shoten Publishing), Takashimaya, Kyoto Station Building, Shueisha, Andersen Institute of Bread and Life, Magazine House, Futabasha Publishing, Mitsukoshi, Odakyu Department Store, and many more…

1. Happy Holidays

AA1-06-030

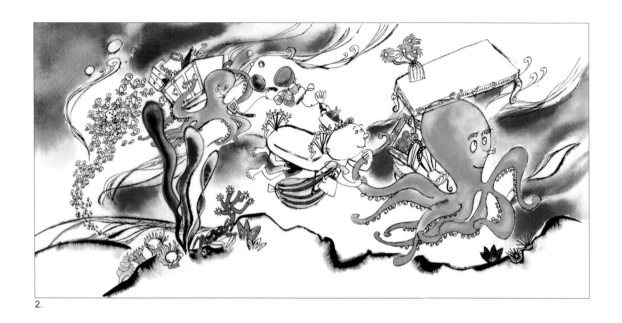

2.

4.

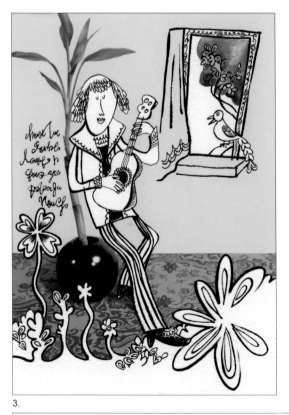

3.

2. The Move 3. Happy Guitar 4. Seaside Road

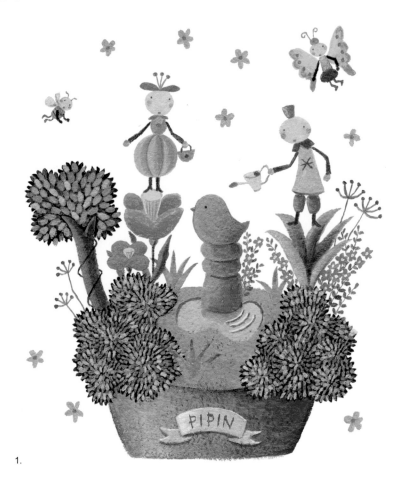

1.

Keiko HONGO

E-mail: keiko_hongo@ARTas1.com
URL: http://www.ARTas1.com/info/keiko_hongo

skill: **W** ☑ **O** ☐ **A** ☑ **P** ☐ **C** ☐ **D** ☐

Time flows luxuriously in the idyllic world of Pipin, an "easy-going, thoroughly relaxed" realm inhabited by the adorable creatures that Ms. Hongo has created. The artist claims her creativity is not spurred by competition, but by her immediate environment, backyard, sweets, and friends. These principles help her create illustrations and characters that possess a charming intimacy, winning her loyal audiences. Her illustrations have appeared in a wide range of media including posters, calendars, stamps, book covers, and packages.

CLIENTS

Calendars, posters, and stamp illustrations: Shiseido, Hobson's, Morinaga, Japan Expo in Miyagi '97, Japan Post, Osaka Gas, and many more… **Publications:** KK Bestsellers **Nanairo (Seven-colored) Therapy** and many more…

AWARDS & SHOWS

National Shinkin Bank PR Concour '97 Calendar Category Highest Award; Kodansha Doga (picture for children) Festival '92 Honorable Mention; and many more… Selected exhibitions at e-space **Calendar**; Aoyama Pinpoint Gallery (Tokyo) **Pipin Four Seasons Calendar**; Tohoku Illustrators Club; and many more…

1. The Secret Garden

AA1-06-031

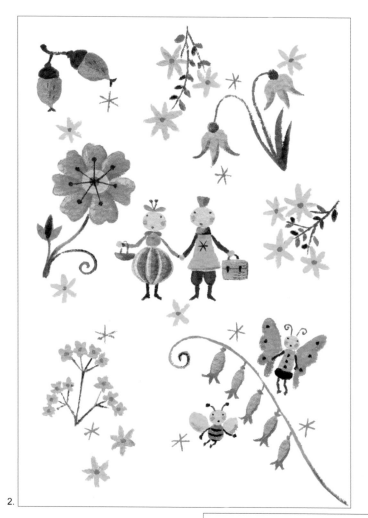

2.

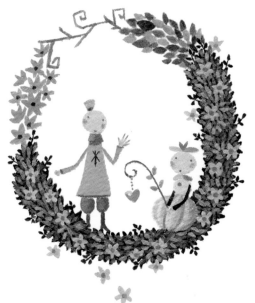

3.

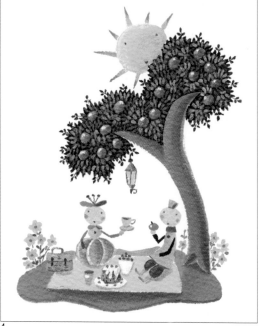

4.

2. Flowering Grasses 3. The Green Ring 4. A Tea Party in Spring

Tetsuya KITADA

E-mail: tetsuya_kitada@ARTas1.com
URL: http://www.ARTas1.com/info/tetsuya_kitada

skill: **W**☐ **O**☐ **A**☑ **P**☐ **C**☐ **D**☐

Design B.A., Tama Art University, Tokyo

"What I have to do is to create powerful and charming illustrations with great qualities. That's it." Mr. Kitada's audience-friendly avant-garde style illustrations have appeared in numerous magazines and on television, and are widely appreciated in Japan. "What you see is what you get, so I want my audiences to feel free to choose what they see in my work." Next year he will publish a book that is a mixture of picture books and *manga*. "Everyday I want to create better than the day before."

CLIENTS
NTT DoCoMo, LOTTE, Nippon Broadcasting System, Fuji Television Network (program character) P-chan, Kodansha, and many more... Publications: Rap·City, Neko Channel (Cat Channel)

AWARDS & SHOWS
NY Festival Design & Print Outdoor Advertising '99 Gold World Medal (Mitsubishi VCR Illustrations for Packaging Design). He has had several solo shows and participates in the Tokyo Illustrators Society exhibitions annually.

Child's Room
© 2006 Tetsuya Kitada

AA1-06-032

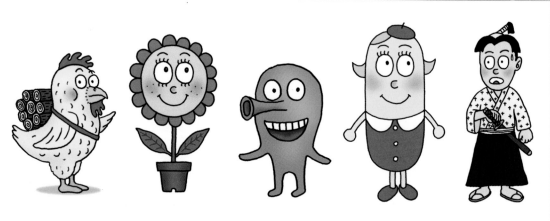

Child's Room & Characters

ARTas1™

Hardcore T-Shirt Designs

© 2006 Tetsuya Kitada

Hardcore Drawings & Collage

1.

AKIRA

E-mail: akira@ARTas1.com
URL: http://www.ARTas1.com/info/akira

skill: **W** ☑ **O** ☐ **A** ☑ **P** ☐ **C** ☐ **D** ☑

Tokyo National University of Fine Arts and Music

Mr. AKIRA's witty and stylish images deliver clear visual messages to viewers. His works seem simple, yet simultaneously attain the depth of fine art. Like many contemporary illustrators, Mr. AKIRA finishes his creative processes digitally, yet his primary medium is cardboard and the textures he applies are unique, neo-nostalgic touches with urban, utopian colors. As an illustrator and a graphic designer, he has worked extensively in fields ranging from advertising to publication and packaging.

CLIENTS
Toyota, Sony Entertainment, Toshiba EMI, Shiseido, Mitsubishi Heavy Industries, Toshiba Engineering, Meiji Dairies, Kodansha, DC Card, Idemitsu Kosan, Shueisha, Obunsha, ASCII, Magazine House, Parco, and many more…

AWARDS & SHOWS
Awards from the Japan Graphic Exhibition and more.

1. Regret

AA1-06-033

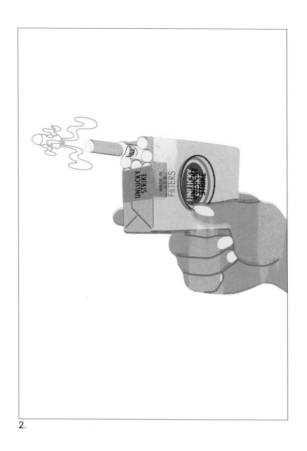

2.

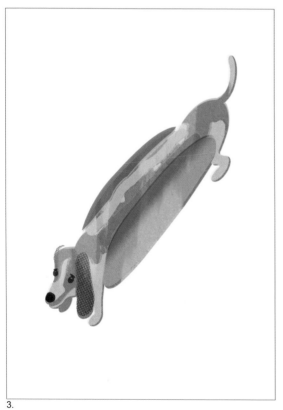

3.

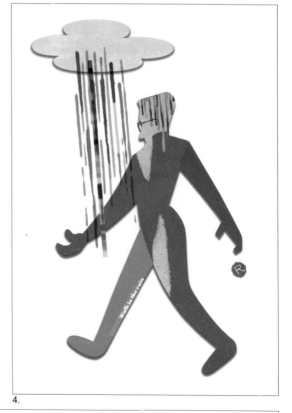

4.

2. Unlucky Strike 3. Hot Dog 4. Walking in the Rain

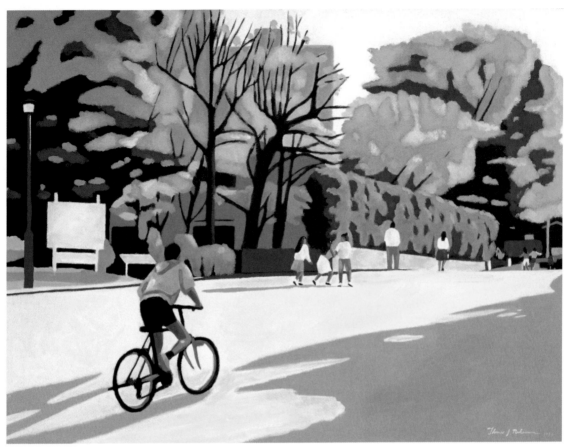

1.

Thomas NAKAMURA

E-mail: thomas_nakamura@ARTas1.com
URL: http://www.ARTas1.com/info/thomas_nakamura

skill: W☐ O☐ A☑ P☑ C☐ D☑

Tokyo Designer Gakuin College

"My ultimate goal is to fuse graphic design and illustrations harmoniously," says Mr. Nakamura. He is a versatile artist who has worked in fields ranging from illustration to graphic design, web design, and digital design for media interfaces. In his works, scenes of the big city are imbued with contrasting atmospheres of vitality and weariness, delight and sadness, and clamor and stillness.

CLIENTS
Illustrations: Sony, CBS Sony, Bridgestone, Yamaha, Honda, Epic Sony, Volvo, and many more...
Graphic Design: Dentsu, Japan Telecom, The Daiichi Mutual Life Company, Yakult Honsha, and many more...
Digital Design: NEC Japan, Japan Broadcasting Corporation (NHK), and many more...
Web Design: Eco Watching.com and more...

AWARDS & SHOWS
Japan Creators Association Competition Prize; EAUX Exhibition; 40th Anniversary of Universal Declaration of Human Rights Stamp Design Competition Merit Award; and many more...
Exhibitions at Harajuku Sekiun Gallery, Yamawaki Gallery, Aoyama Pinpoint Gallery (Tokyo), and many more...

1. Crisp Early Summer

AA1-06-034

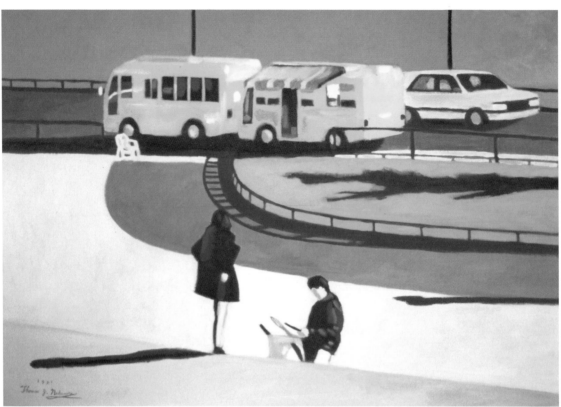

2.

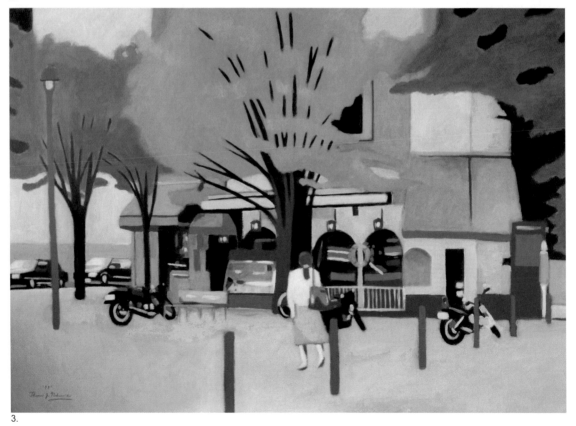

3.

2. Yellow Wagons 3. Visual Scene of a Port Town

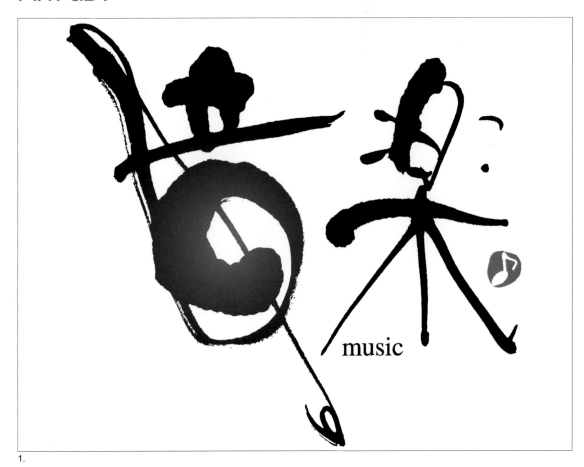

music

1.

Mihoko INAZAWA

E-mail: mihoko_inazawa@ARTas1.com
URL: http://www.ARTas1.com/info/mihoko_inazawa

skill: **W**☐ **O**☐ **A**☐ **P**☐ **C**☐ **D**☑
Other (Calligraphy)

Design B.A., Tama Art University, Tokyo

"To work happily I need to keep myself in a neutral state... then I can create true images. When I work on a project, it is the *yohaku* (the blank space) that I am vividly aware of. *Ma* and *kuki* (the space and air between things) are universal in compositions and I think everyone can perceive this." With fluid forms made from rich brush strokes, Ms. Inazawa's illustrations possess a distinguished grace. Her works have appeared in character designs, calendars, and picture books, and they all have a special warmth that reaches out to audiences. Ms. Inazawa also enjoys her gift and established reputation in calligraphy.

CLIENTS
JALUX (JAL Group) and Japan Airport terminal (lunch box packaging), CO-OP, Polan Organic Foods Delivery, Kamakurayama Natto, and many more...

1. Music

AA1-06-035

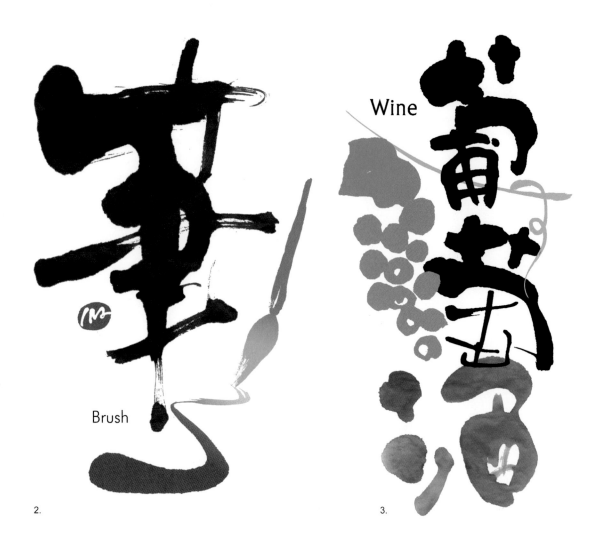

Wine

Brush

2.

3.

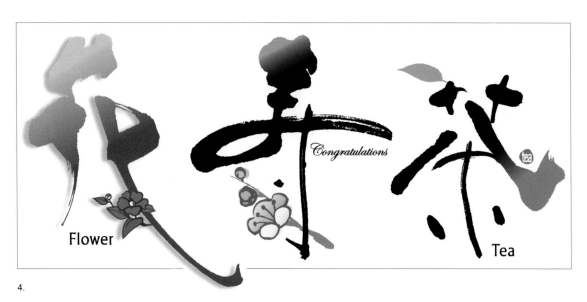

Flower

Congratulations

Tea

4.

2. Brush 3. Wine 4. Flower, Congratulations, Tea

NEW YORK

5.

6.

5. New York 6. Kaito (Boy) and Sora (Girl)

日本の米

RICE

妖精

Fairy

7. 8.

7. Japanese Rice 8. Fairies Pupian and Cooky

1. 2.

Shuji YAMAMOTO

E-mail: shuji_yamamoto@ARTas1.com
URL: http://www.ARTas1.com/info/shuji_yamamoto

skill: **W** ☐ **O** ☐ **A** ☑ **P** ☐ **C** ☑ **D** ☑

As an emerging illustrator, Mr. Yamamoto has rapidly gained a reputation and expanded his clientele into the fields of commercial animation, magazines, and advertising. Transcending culture and nationality, he attempts to represent the universal hipness of Japan as well as its sensitivity with a mix of graffiti and fine art styles. Bold lines and vivid colors are vital to his creations. Mr. Yamamoto lives and works in New York City.

CLIENTS

Toyota, Seikatsusoko, Oasis 21, Murasaki Sports, ZIP-FM (Nagoya), Men's Bigen.

AWARDS & SHOWS

Menio Highest Award ('97).

1. Samurai Santa 2. Gizoku Santa

AA1-06-036

3.

4.

5.

6.

3. Tough Guy 4. The King of New York 5. Please 6. Escape

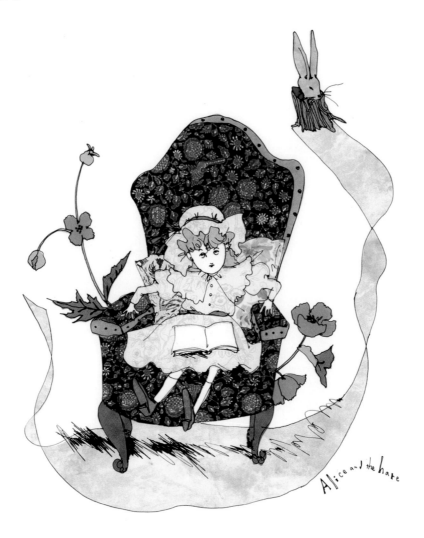

1.

Megumi ASAKURA

E-mail: megumi_asakura@ARTas1.com
URL: http://www.ARTas1.com/info/megumi_asakura

skill: **collage, pen drawing**

Fine Art B.A., Tama Art University, Tokyo

Ms. Asakura's sophisticated, flowing lines are adorned by vibrant colors created from a collage of origami and colored papers. She excels at capturing human poses, and her characters become eloquent subjects of human nature. "I enjoy illustrating subjects such as fairy tales and classical literature, but as long as I create, my outlook should be that of a contemporary artist." Ms. Asakura's art has adorned the covers of numerous major magazines and books, especially Japanese versions of international bestsellers such as **Bridget Jones' Diary** (Helen Fielding, published by Sony Magazines).

CLIENTS

YAMAHA, Dentsu, Sony Magazines, Japan Airlines, Shogakukan, Japan Broadcasting Corporation (NHK), Shuesha, Recruit, Shinchosha, and many more... **Covers for titles of Japanese versions:** *The Man Who Ate Everything* (Jeffrey Steingarten), *Take Your Time* (Eknath Easwaran), *Junk* (Melvin Burgess), *The Trail to Buddha's Mirror* (Don Winslow), *Mom Among The Liars* (James Yaffe), and many more...

1. Alice and the Hare

AA1-06-037

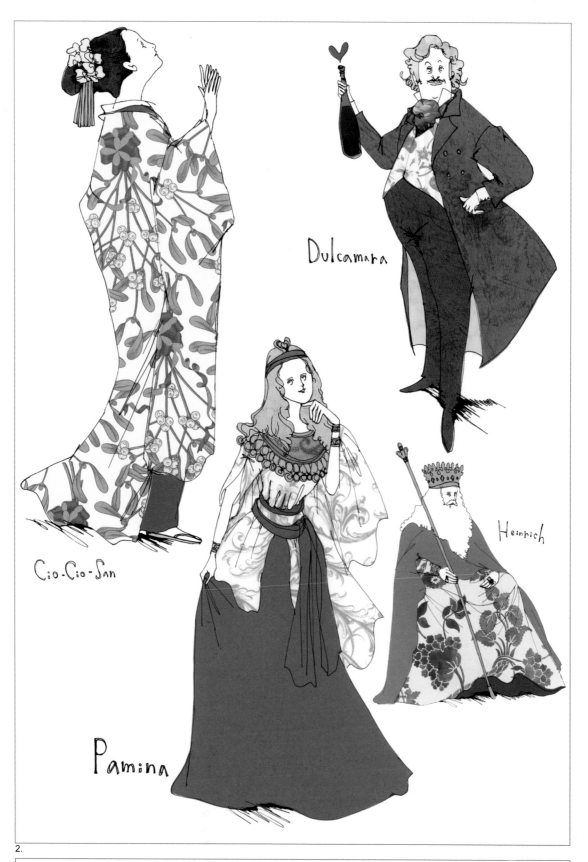

Dulcamara

Cio-Cio-San

Heinrich

Pamina

2.

2. Opera Gallery

3.

4.

5.

3. Snow White 4. Contemporary Snow White 5. Cooking Dance (Animated for TV)

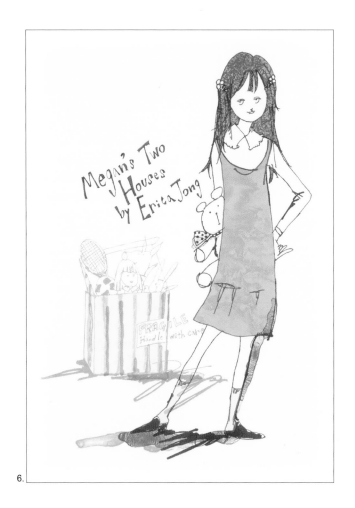

6.

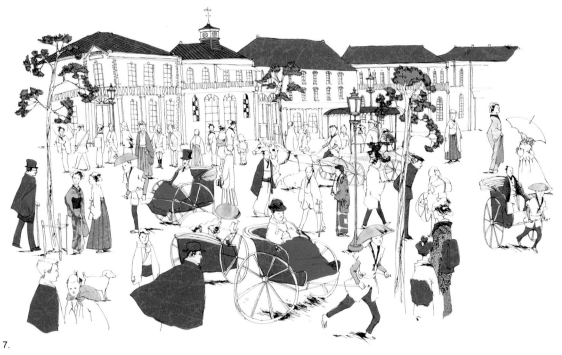

7.

6. Megan's Two Houses 7. Cultural Enlightenment

1.

Kenji YUNO

E-mail: kenji_yuno@ARTas1.com
URL: http://www.ARTas1.com/info/kenji_yuno

skill: **W**☐ **O**☐ **A**☐ **P**☑ **C**☐ **D**☐

Design B.A., Musashino Art University, Tokyo

"I paint with layers and layers of pastels and feel that their profound soft tones and hues are at the core of my creations." Mr. Yuno is fascinated by the beautiful color of pastels, and his audiences have been captivated by his works as well. Mr. Yuno's graceful and dignified female figures have appeared on numerous posters, brochures, CD covers, calendars, book covers, and national advertising campaigns. His illustrations for the Japanese movie **Chirusoku no Natsu** (**The Stars Converge**, Dir. Kiyoshi Sasabe) have gained him international acclaim.

CLIENTS

CBS Sony, Toshiba EMI, Victor Company of Japan, McDonald's Japan, Avon, Kanebo, Takashimaya, Kose, Combi Corporation, Sumitomo Mitsui Card (Visa), Sunroute Hotel, Chain, MIMAKI Engineering, and many more...

AWARDS & SHOWS

Sekiun Gallery (Tokyo) **Calendars**; Bartok Gallery (Tokyo) **New Years' Card**; Yamawaki Gallery (Tokyo) **Works**; Solo shows at Gallery House MAYA and many more...

1. Winter

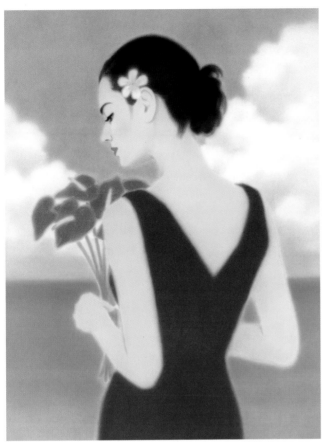

2.

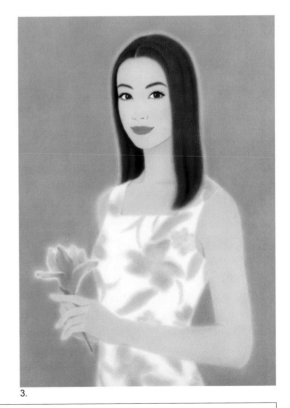

3.

2. Summer 3. Magnolia

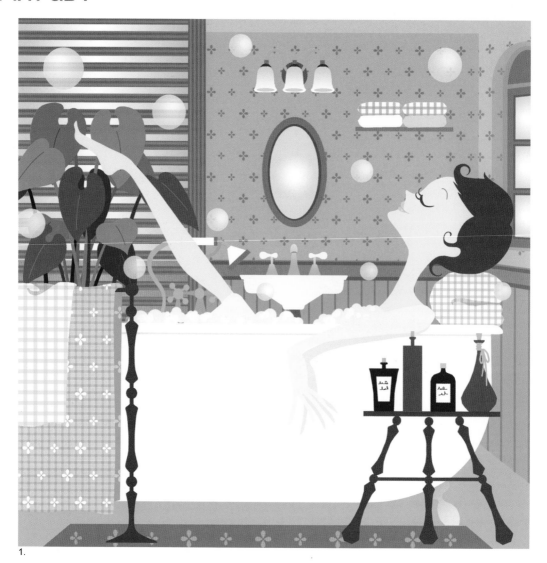

1.

Naoko MATSUNAGA

E-mail: naoko_matsunaga@ARTas1.com
URL: http://www.ARTas1.com/info/naoko_matsunaga

Esmod Japon, Tokyo

skill: **W**☐ **O**☐ **A**☐ **P**☐ **C**☑ **D**☐

"I would like to have as many adventures as possible and to create significant works in the future," says Ms. Matsunaga. Trained in fashion and art, her concepts are clear, witty, and classy, making for very attractive illustrations. As an emerging illustrator, she has just begun her endeavors. She lives and works in Los Angeles.

CLIENTS

LA Style Dog Wear, Los Angeles–based Japanese magazine **LOVEST**, and more...

1. It's Bath Time

AA1-06-039

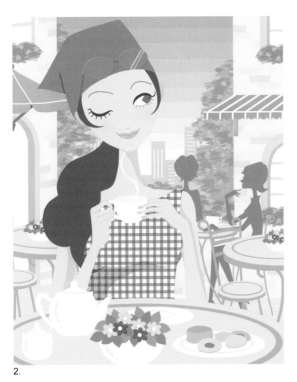

2.

3.

4.

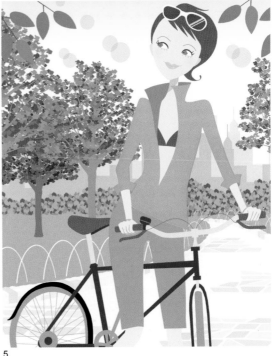

5.

2. Tea Time 3. The Spa 4. Christmas Party 5. Bicycling

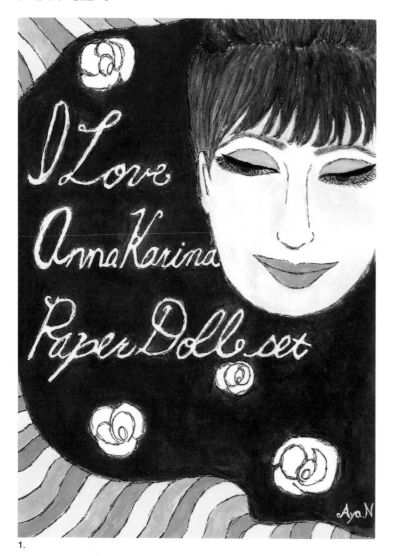

1.

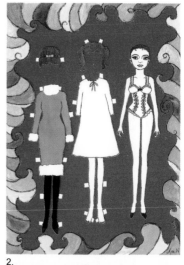

2.

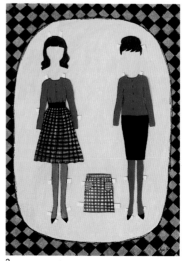

3.

Aya NAKAISHI

E-mail: aya_nakaishi@ARTas1.com
URL: http://www.ARTas1.com/info/aya_nakaishi

skill: **W** ☑ **O** ☑ **A** ☑ **P** ☐ **C** ☐ **D** ☐

"I think my sensitivity comes from my identity as a Japanese, and that influences the way I view and perceive different cultures in the States. This is reflected in my works, which are a mixture of reality and fiction. It's kind of like a fairy tale," says Ms. Nakaishi. "I remember the feeling of getting pulled into stories that my parents read to me as a child and I know those memories have a very strong influence on my contemporary works." Ms. Nakaishi lives and works in Los Angeles.

CLIENTS
Label designs for LL Bakery (Los Angeles), and more...

1. Anna Cover　　2. Une Femme est Une Femme　　3. Une Femme est Une Femme 2

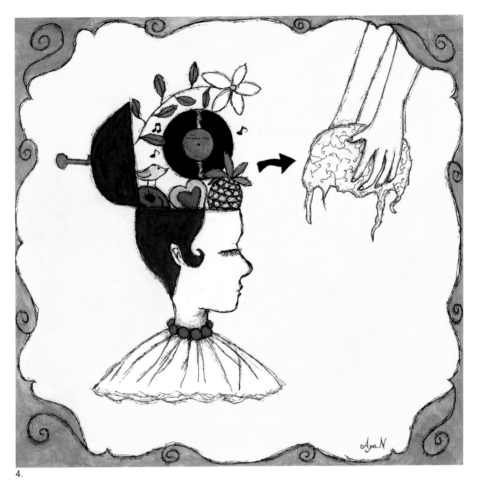

4.

5.

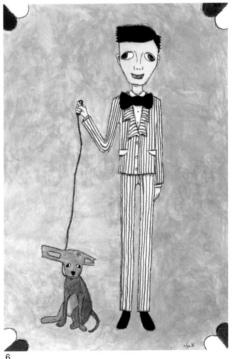

6.

4. Maintenance 5. Mini Devil 6. Mr. Pop

1.

Mari MITSUMI

E-mail: mari_mitsumi@ARTas1.com
URL: http://www.ARTas1.com/info/mari_mitsumi

skill: **W**☐ **O**☐ **A**☑ **P**☐ **C**☐ **D**☑

"I like to infuse universality into the individuals in my work so that audiences can project their own feelings." Using sophisticated images, Ms. Mitsumi's illustrations evoke a cinematic approach, in which each protagonist conveys intricate emotions yet addresses the audience serenely. Her works are the result of an elaborate process that begins with painting acrylic on canvas, scanning the painting, and finishing up digitally. She has collaborated with various clientele in editorial, broadcasting, IT, and advertising for major corporations. Her illustrations were selected by *Illustration Now!* (published by TASCHEN, editor: Julius Wiedemann) which showcases commercial and editorial illustrators from over fifty countries.

CLIENTS

Columbia Music Entertainment, Kellogg Japan, Toshiba, GQ Japan, Shiseido, DHC, Kadokawa Shoten Publishing, Kodansha, Shueisha, Tokuma Shoten Publishing, Nihon Keizai Shimbun, The Asahi Shimbun, SoftBank, Infobahn, Impress, and many more...

1. Bird on the Wire (Cropped)

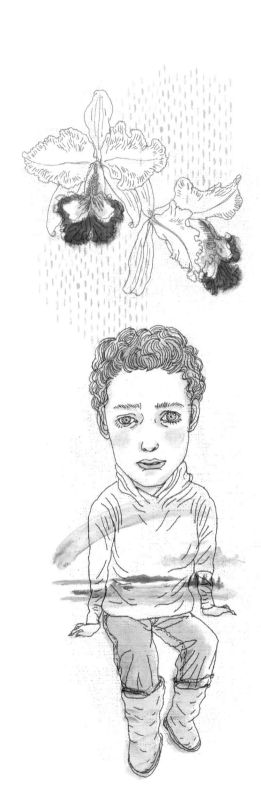

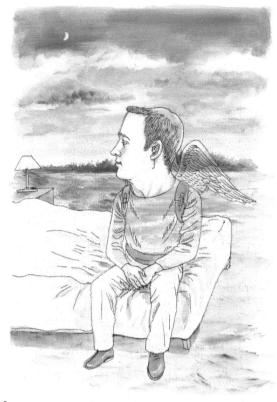

3.

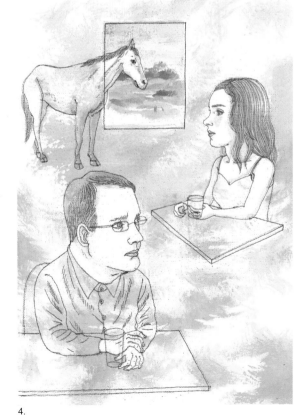

2.

4.

2. The Orchids and the Rainbow 3. The Role 4. Synchronicity

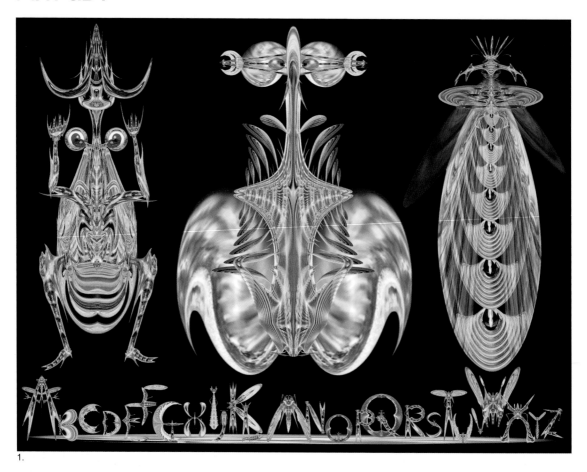

1.

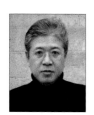

Sad MORI

E-mail: sadahito_mori@ARTas1.com
URL: http://www.ARTas1.com/info/sadahito_mori

skill: **W**☐ **O**☐ **A**☑ **P**☐ **C**☑ **D**☑

For Mr. Mori and his revolutionary creations, the computer is an important bridge between mind and art. "To me, a computer is a tool I use to crystallize my imagination visibly." While his mysterious insects lure us into a fantasy, his exquisite neo-Japanese style calls forth the beauty of nature. *Kusou Konchu (Imaginary Insects)* is his latest innovation and has received international acclaim. He is establishing an Internet museum called *Kusou Konchu Zukan (The Book of Imaginary Insects)* and he would like to develop them into animation. "To create all-new visual images that no one has ever seen before is absolutely wonderful. So I have to keep it up," he says and smiles. He is a member of **the Society of Illustrators** (NY), **the Tokyo Illustrators Society, and the Japan Graphic Designers Association.**

AWARDS & SHOWS

The Art Directors Club (NY) 77th Annual Awards 1998 Merit Award (**Collecting Insects**); Warsaw International Poster Biennial; Asia Digital Art Award Grand Prize; Japan Media Arts Festival (the Committee Nominee); Epson Color Imaging Contest Epson Award; The International Triennial of Poster in Toyama; and many more…

1. Imagination: Insects of the Alphabet

AA1-06-042

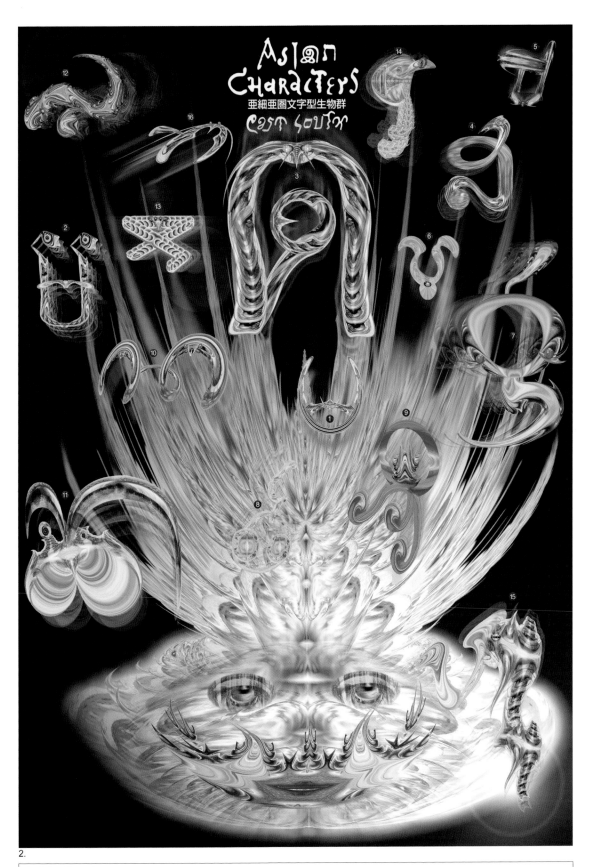

2.

2. Asian Characters

3.

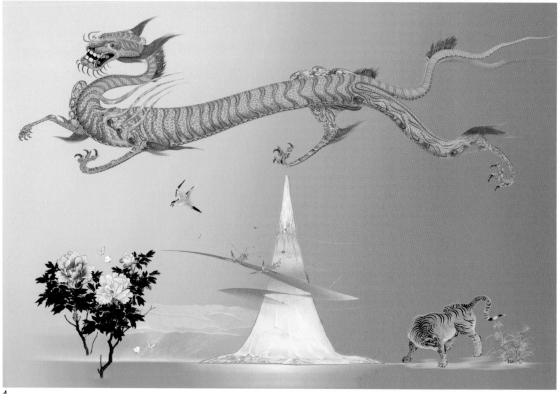

4.

3. Japanism Style 4. Japanism Style

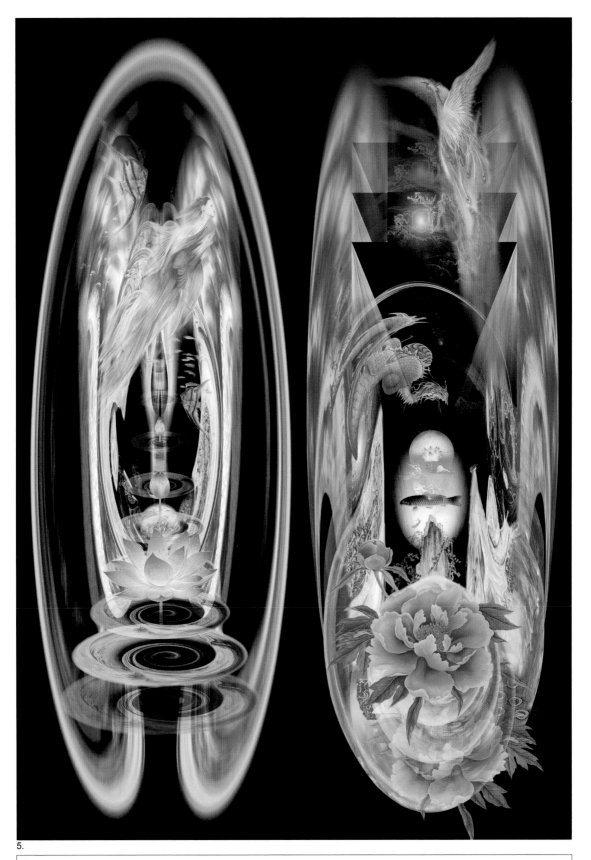

5.

5. Japanism

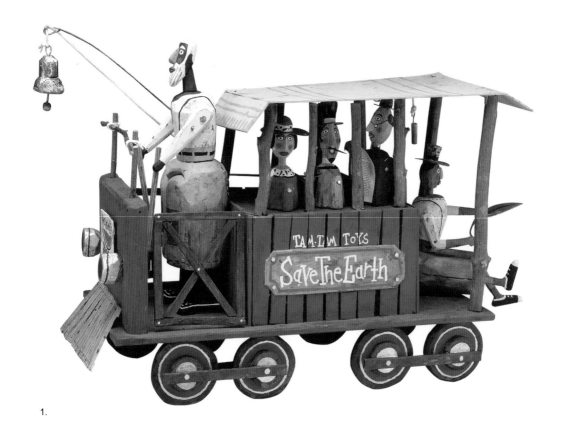

1.

Eiji TAMURA

E-mail: eiji_tamura@ARTas1.com
URL: http://www.ARTas1.com/info/eiji_tamura

skill: **3-dimensional**

Nihon University Collage of Art, Tokyo

Mr. Tamura refers to himself as a diorama artist. Reminiscent of a bright version of the Brothers Quay, his dioramas portray quirky and intricate portraits and scenes of characters engrossed in activities. His illustrations have appeared in a wide range of media and a broad array of advertising, including magazines, posters, corporate advertising campaigns, and publications.

CLIENTS
Honda, Mazda, Mitsubishi, All Nippon Airways (ANA), Japan Association for the 2005 World Exposition, Ministry of Land Infrastructure and Transport, Japan Broadcasting Corporation (NHK), Tokuma Japan Communications, and many more…

AWARDS & SHOWS
He has won various calendar/poster competitions and illustration awards in Japan.
Selected solo shows at Ginza Itohya Gallery(Tokyo) **Tamura Eiji 3-D Art**; Numashin Street Gallery (Shizuoka) **Diorama Box**; AEON Hall (Shizuoka) **2004 X'mas 3D Art Exhibition**; Matsuzakaya (Shizuoka) **Tamura Eiji 3D Art Exhibition**; Takashimaya (Osaka) **TAM-TAM World 3D Art Exhibition**; and many more…

1. TAM TAM Toy

AA1-06-043

TAMTAM—TOYS

EIJI TAMURA

2.

2. TAM TAM Toys

Comments from Supporters

Welcome, artists. I have always enjoyed illustration coming from Japan for its eye-catching appeal and professionalism. I look forward to seeing you join other emerging artists in the U.S. market. Your unique point of view and cultural perspective can only raise the standard of creativity here. I especially enjoy the Japanese approach to character development, comics, and humorous art, and look forward to seeing those influences impact American advertising and design. I wish you all good luck and continued success in your illustration careers.

Mike Quon
Owner, Quon | Designation
USA

ART as 1™ - Japanese Professional Illustrators Vol. 1 will serve as a great resource to American advertising and design professionals looking for a talent in Japan especially for projects that are more geared towards the Eastern market. I am confident that this book will be a great and helpful guide to the American illustrators and designers to find out more, at one place, about what the trends are in the Japanese illustration world. We are continuously exposed to different cultural influences in today's global market place, but it is also important that we get a chance to see a good selection of quality work. My hope is that with *ART as 1™ - Japanese Professional Illustrators Vol. 1*, we will see more of the great talent exchange between the two countries.

Vesna Petrović
AIGA board member
Graphic Designer
Founder and Partner at Picnic Design studio (L.A.)
Founder of three design (de3ign) studio (L.A.)
Board Member of AIGA Cross Cultural Design Group
http://www.de3ign.com

I strive to be real, genuinely human, and live legitimately. Ever since I turned 40, I have pursued this existential proposition. But the daily reality of deadlines and budgets that surround commercial design and visual art make it even more difficult for artists to create great works of quality. However, I strongly believe in the authenticity of genuine art, whose value is appreciated globally, because world-class art transcends all kinds of barriers and is loved by people through the ages. The artists presented in this book are striving towards crystallizing this dream. I am proud to showcase these artists and wish them success in the international community!

Makoto Ohtsuki
President
Coconuts Crash, Inc.

At Giant Robot, we have been supporters of the *Art as 1*™ online art journal since its beginning. From the pop *yokai* sculpture of Yukinori Dehara to the unstoppable drawings of Gary Baseman, the Los Angeles-based site has shown both diverse and discerning taste in covering the arts. Of course we were thrilled to find out about the *ART as 1*™ book, which provides a well-chosen sampling of exciting and up-and-coming artists from Japan. The classy publication features an amazing selection of character design, 2-D comics, digital rendering, editorial illustration, and other styles, and is an excellent source of reference and inspiration.

Giant Robot
Martin Wong & Eric Nakamura
http://www.giantrobot.com

enjoy giant robot

1994: giant robot magazine po box 641639 LA, CA 90064
2001: giant robot los angeles 2015 Sawtelle Blvd 310.478.1819
2003: giant robot 2 2062 Sawtelle Blvd 310.445.9276 gr2.net
2003: giant robot san francisco 622 Shrader St. SF 415.876.GRSF
2005: gr/eats restaurant 2050 Sawtelle Blvd 310.478.3242 gr-eats.com
2005: giant robot silverlake 4017 Sunset Blvd 323.662.GRLA
2005: giant robot new york 437 East 9th Street NY grny.net
2006: giant robot magazine goes bi-monthly

giantrobot.com

Brightly colored liquid ink flows easily, dries quickly, and produces transparent watercolor effects.

Create dreamy watercolor paintings; make your illustrations stand out.

Ink-filled brushes for nonstop painting.
Neater than a traditional brush and paint.

ART as 1™

Bringing Japanese Art to the USA

Illustration & Visual Fine Arts
Sales & Licensing

for Ad Agencies, Art Directors, Art Galleries,
Publishers and Licensee Manufacturers

Advertising • Animated Feature Films
Apparel • Brand Art • Calendars • Characters
Children's Illustrated Books • Clocks/Watches
Comics/Anime/Graphic Novels • Conceptual Art
Corporate Art • Covers for Books/CDs/DVDs/
Magazines/Video Games • Digital Contents
Dolls & Figures • Editorials • Fine Arts • Foods
Gifts • Graphic Design • Greeting Cards
Health & Beauty • Home Décor & Housewares
Large Scale Installations • Movie Posters PC
Games • Publishing • Script Illustration
Stationery • T-Shirts • Toys • TV Commercials
Wireless Contents, and much more...

ART as 1™

E-mail: ask@ARTas1.com www.ARTas1.com
Los Angeles Headquarters: 970 W. 190th St., Suite 270 Torrance, CA 90502
Tel: 310.515.7100 Fax: 310.515.7188
New York Office: Empire State Building 75th Floor, 350 Fifth Ave., Suite 7500, NY, NY 10118
Tel: 212.736.5046 Fax: 212.504.8046

ARTas1™

Japanese Professional Illustrators - Vol.1

For all English inquiries,
Please contact: **Paul A.Whitney**
e-mail: paulw@ARTas1.com

Headquarters - Los Angeles
970 W. 190th St., Suite 270
Torrance, CA 90502 U.S.A.
Tel: 310.515.7100 Ext. 102
Fax: 310.515.7188

New York Office
Empire State Building, 75th Floor
350 Fifth Ave., Suite 7500
New York, NY 10118 U.S.A.
Tel: 212.736.5046
Fax: 212.504.8046